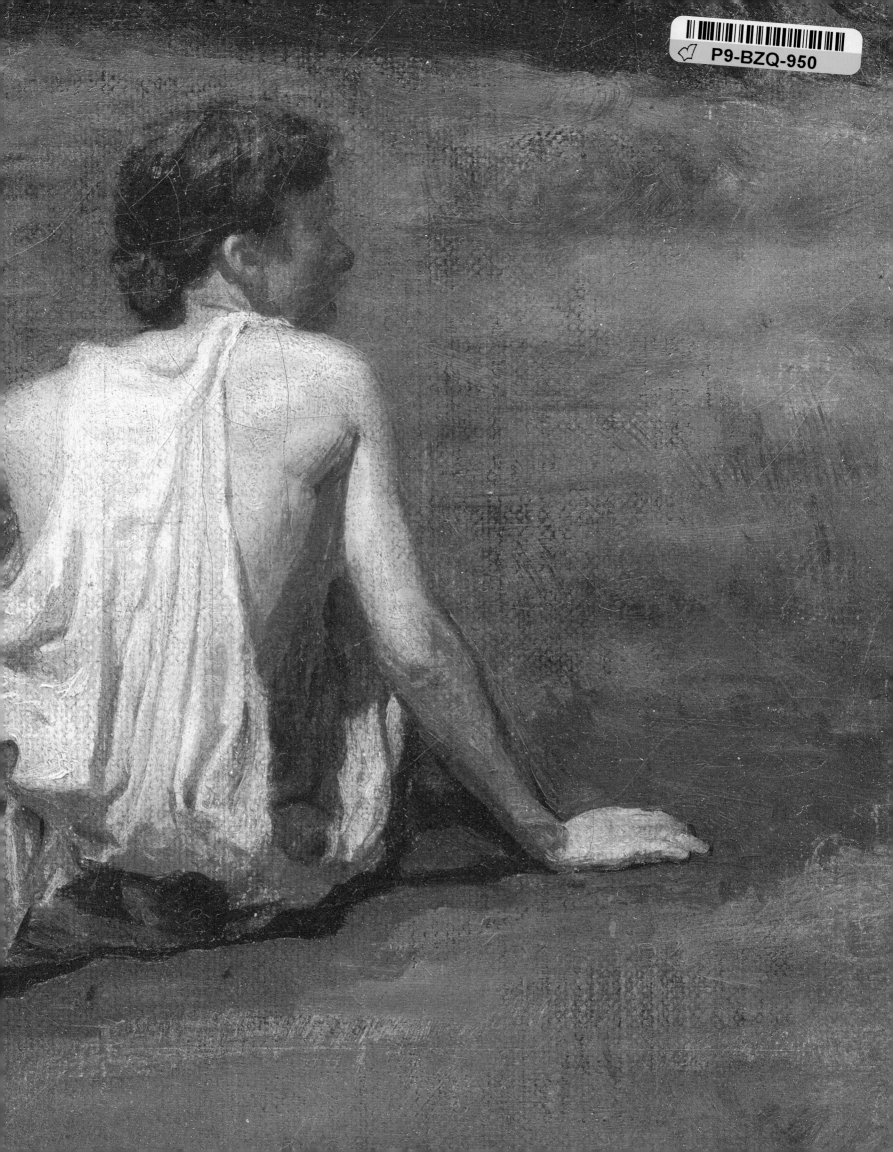

William Merritt Chase

(1849–1916)

Thomas Cole

(1801–1848)

Willem de Kooning

(1904–1997)

Thomas Eakins

(1844–1916)

Sanford Robinson Gifford

(1823–1880)

Childe Hassam

(1859–1935)

Robert Henri

(1865–1929)

Chauncey Bradley Ives

(1810–1894)

Fitz Hugh Lane

(1804–1865)

Frederic Remington

(1861–1909)

Theodore Robinson

(1852–1896)

John Henry Twachtman

(1853–1902)

Twelve
American Masterpieces

These works may be viewed by appointment.

Spanierman Gallery, LLC

45 East 58th Street New York 10022 Tel (212) 832-0208 Fax (212) 832-8114

Email info@spanierman.com www.spanierman.com

COVER:
Sanford Robinson Gifford, *Autumn in the Catskills* (detail of Cat. 3)

ENDLEAF:
Thomas Eakins, *An Arcadian* (detail of Cat. 5)

Published in the United States of America in 1998 by
Spanierman Gallery, LLC, 45 East 58th Street, New York, NY 10022.

ISBN 0-945936-20-6

Contents

Acknowledgments

THIS CATALOGUE has been a truly collaborative effort, and we would like to thank the many individuals who generously provided their time and help. Our first thanks are due to the contributors, who wrote thoughtful essays and readily answered numerous research questions. For their assistance with documentation on the works, we would like to express special gratitude to Professor William H. Gerdts, City University of New York, for sharing his personal library; to Cecilia H. Chin, librarian, National Portrait Gallery/National Museum of American Art Library, Smithsonian Institution, Washington, D.C., for checking catalogues and facts; and to John Devine, Microtext Department, Boston Public Library, Massachusetts, who searched through reels of microfilm on our behalf.

We would also like to thank Alf Evers, Shady, New York; Lynya Floyd, assistant to the editor, *The Magazine Antiques*, New York; Nancy Malloy, reference specialist, and Valerie Komor, archivist, Archives of American Art, Smithsonian Institution, New York office; Courtney G. Donnell, associate curator, Twentieth-Century Painting and Sculpture, The Art Institute of Chicago; Evelyn Lannon, and Kim Tenney, fine arts librarians, Fine Arts Reference Department, Boston Public Library; Irene Roughton, associate registrar, and Steven A. Eichner, library manager, Jean Outland Chrysler Library, Chrysler Museum of Art, Norfolk, Virginia; Harriet Memeger, head librarian, Delaware Art Museum Library, Wilmington; Lydia Dufour, administration and reference correspondence, Irene Avens, head, Reference Department, and Teresa Moyer, reference assistant, Reading Room, Frick Art Reference Library, New York; Wendy A. Rogers, registrar, The Hudson River Museum, Yonkers, New York; Jacqueline Dugas, registrar, Huntington Library, Art Collections, and Botanical Gardens, San Marino, California; Melissa De Medeiros, librarian, Knoedler & Company, New York; Jennifer Tolpa, reference librarian, Massachusetts Historical Society, Boston; Patty Martinson, administrative assistant, Department of Paintings, The Minneapolis Institute of Arts, Minnesota; Laila Abdel-Malek, library manager/technical services, Museum of Fine Arts, Boston; Jennifer Tobias, associate librarian, Reference, The Museum of Modern Art Library, New York; Pat Lynagh, reference librarian, National Portrait Gallery/National Museum of American Art Library, Smithsonian Institution, Washington, D.C.; Cathi

Quintana, collections manager, Shelburne Museum, Vermont; Claudia Irvine, registrar, Center for the Arts, Vero Beach, Florida; Ed Russo, associate registrar, Wadsworth Atheneum, Hartford, Connecticut; and Laura Mills, curatorial assistant, American Art, Worcester Art Museum, Massachusetts.

Numerous individuals are owed thanks for helping us to procure photographic material. They include: Susan Benedetti, registrar, The Haggin Museum, Stockton, California; Jan Brenneman, director, Sid Richardson Collection of Western Art, Fort Worth, Texas; Amy Densford, photography coordinator, Hirshhorn Museum and Sculpture Garden, Washington, D.C.; Holger Gehrmann, Artothek, Munich; Josette van Gemert, Reproduction Department, Van Gogh Museum (Vincent van Gogh Foundation), Amsterdam; Joanne Greenbaum, Art Resource, New York; Elizabeth Holmes, associate registrar, Buffalo Bill Historical Center, Cody, Wyoming; Ruth Janson, Rights and Reproductions, Brooklyn Museum of Art, New York; Barbara Katus, manager, Rights and Reproductions, Pennsylvania Academy of the Fine Arts, Philadelphia; Alicia Longwell, registrar, and Renee Minushkin, curatorial assistant, Parrish Art Museum, Southampton, New York; Mandy Marks, Senior Picture Library assistant, National Gallery, London; Susanne McNatt, Interlibrary Services librarian, Princeton University, New Jersey; Kerrie Moore, university archivist, University of Dayton, Ohio; Denise Morax, Registrar, Thyssen-Bornemisza Foundation, Lugano, Switzerland; Karen Otis, Photographic Services Department, Museum of Fine Arts, Boston; Elwood C. Parry III; Howell W. Perkins, manager, Department of Photographic Resources, Virginia Museum of Fine Arts, Richmond; Bennard B. Perlman; Emily S. Rosen, Product Development Manager, The Cleveland Museum of Art, Ohio; Jeffrey Sacchet, 21 Club, New York; Cristina Segovia, Rights and Reproduction, The Corcoran Gallery of Art, Washington, D.C.; Dimitris Skliris, Photographic Services Office, Wichita Art Museum, Kansas; Meredith Sutton, Associate Registrar, Jack S. Blanton Museum of Art, The University of Texas at Austin; Hollis Taggart Gallery, New York; Suzanne Warner, Department of Rights and Reproductions, Yale University Art Gallery, New Haven, Connecticut; Nick Wise, Victoria and Albert Picture Library, Victoria and Albert Museum, London; Patricia J. Whiteside, Registrar, The Toledo Museum of Art, Ohio; Sharon Worley, curator, Cape Ann Historical Association, Gloucester, Massachusetts; and Julie Zeftel, Photograph Library, Metropolitan Museum of Art, New York.

In addition, the entire staff of Spanierman Gallery, LLC deserves credit for their participation in this publication. In particular, we would like to thank Aelana Curran, archivist, for her work on documention, Jessica May, research assistant, for organizing illustrations and permissions, and Ellery Kurtz, for overseeing photography. We are also grateful to Fronia W. Simpson, who edited this catalogue with care and insight, and to Marcus Ratliff and Amy Pyle for their usual excellent design and production work.

Lisa N. Peters
Director of Research
Catalogue Coordinator

Sandra Feldman
Research Associate
Documentation Coordinator

A Personal Statement

by William H. Gerdts

W HEN I MET Victor Spark in 1949, I was working at the Mead Art Museum, the gallery of my alma mater, Amherst College. He was the first art dealer I ever came to know, and it was a fortunate meeting in many ways, not least because right then I came to realize that art dealers, the best of them anyway, were often as or more perceptive and knowledgeable (*both* of those qualities) than a great many museum folk and / or academic art historians. That recognition was underscored during the following three years in graduate school at Harvard University, where my true mentor in American art and its history was, not any of the faculty, but Bob Vose, at the Vose Galleries in Boston.

Subsequently, during my twelve years as curator of painting and sculpture at the Newark Museum and the past twenty-eight years with the City University, my appreciation of the great majority of commercial gallery owners and personnel in my field has only grown. I'm not sure, now, when I first met Ira Spanierman, but it was certainly before he had his first public gallery on Lexington Avenue, so he must have been one of the first whom I met in New York, after Victor Spark, that is. Ira and I have remained friends and colleagues for a long, long time, and I have tremendous respect for his visual perspicacity, and great admiration for his devotion to scholarship. The latter is manifested in many ways. He has assisted our Graduate Program in Art History at the City University. He has engaged a large group of talented scholars to research the works of art that have been handled by the gallery, and their printed analyses are often tremendously illuminating. He has mounted a series of impressive exhibitions dealing with both major American artists and those who are little known or have been forgotten, and the catalogues of those shows frequently constitute the major modern monographs, or contribute greatly to the body of knowledge on those painters.

I was pleased to be able to contribute to one such show dealing with the Impressionist artist Frank Benson. I was one of about a dozen scholars who researched and authored the catalogue published in connection with the gallery's exhibition *The Ten American Painters*, the most significant group of Impressionist artists who began exhibiting together at the turn of the century.

Perhaps most impressive of all is the support Ira has given to a series of major catalogue raisonné projects—the accumulation of all the known, pertinent data on Winslow Homer, John Twachtman, Theodore Robinson, Willard Metcalf, and Thomas Hart Benton. Those dealing with Twachtman, Robinson, and Metcalf involve committees that are concerned with matters of authentication, and it is a privilege for me to serve on all three of them. The opportunity to see and examine great works of art is always stimulating, and determining the validity of attributions is always a challenge. It is also a learning experience; it hones the eye, so to speak. But the experience goes further. There are few opportunities more rewarding to an art historian than to study a fine painter's achievement, and examining such works with an experienced connoisseur such as Ira can be revelatory. Ira has a singular way of guiding one through a picture, say by Metcalf or Twachtman, seeing the landscape through their eyes and explaining how they achieved it pictorially with their individual talents and strategies. The riches he gives in this way become a measure of the man.

Thomas Cole (1801–1848)

1. *Sunset on the Arno,* ca. 1838
 Oil on canvas
 33⅝ × 61½ inches

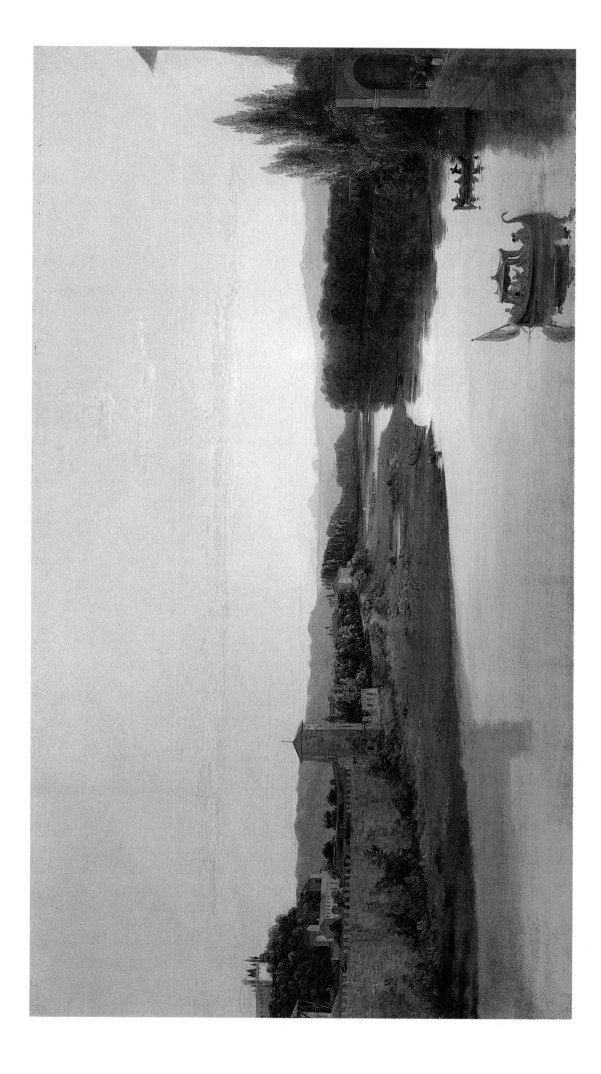

1.

Thomas Cole: *Sunset on the Arno,* ca. 1838

by Elwood C. Parry III

Sunset on the Arno (Cat. 1) offers glowing testimony to how deeply Thomas Cole was still in love with Italy, especially the city of Florence, long after returning from a grand tour of Europe (June 1829–November 1832). The first two years of his sojourn had been spent in England, but that extended stay, prolonged because of the French Revolution of 1830 and the outbreak of cholera on the Continent, remained in his memory as a bleak and fallow period compared to the flowering that followed. He even described the stark contrast between his life in London and his love of Italy in a biographical account sent to William Dunlap. However, much to Cole's professional chagrin, his unguarded critique of English art and artists was published verbatim in Dunlap's *History of the Rise and Progress of the Arts of Design in the United States* (1834):

> I did not find England so delightful as I anticipated. The gloom of the climate, the coldness of the artists, together with the kind of art in fashion, threw a tone of melancholy over my mind, that lasted for months, even after I had arrived in sunny Italy. Perhaps my vanity suffered. I found myself a nameless, noteless individual, in the midst of an immense selfish multitude.... My own works, and myself most likely, had nothing to interest them sufficiently to excite attention: the subjects of my pictures were generally American—the very worst that could be chosen in London. I passed weeks in my room without a single artist entering, except Americans.[1]

By contrast, Italy was a revelation. Once settled in Florence by early June 1831, Cole discovered the magnificence of the art collections; he enjoyed the immediate friendship of fellow countrymen, including artists such as Horatio Greenough and

Francis Alexander; he began to attract an increasing number of patrons from the United States; and he found the perfect "quietness and seclusion" in which to live and work. In short, all these elements made the place, for him, "a painter's paradise."[2]

Cole's delight in these new surroundings is instantly apparent in a fresh sketchbook, dated "June 15th, 1831," containing a sequence of views of Florence, beginning with the obligatory panorama from the top of the hill near the church of S. Miniato al Monte, a view that had already been "staked out" by numerous earlier artists, including J. M. W. Turner (Fig. 1). That Cole's detailed pencil rendering of the scene—inscribed "1/2 hour before sunset"[3]—was drawn across two pages at the beginning of this sketchbook suggests that he was intent on capturing the conventional "postcard" view first, much like a modern tourist determined to take a snapshot at a preapproved location. Six years later, conforming to convention again, Cole worked up this same panoramic drawing into an appropriately large and impressive topographical view for exhibition in New York (Fig. 2).

Much more unusual are companion drawings further on in his 1831 sketchbook that represent the original inspiration for all of Cole's westward views along the Arno.[4] From a later note in the artist's handwriting, it is fascinating to learn that these repeated renderings (one retraced in ink) were actually made from the house of an American patron, Horace Gray, an amateur horticulturist from Boston.[5] As a starting point in midsummer 1831, these much less predictable drawings resulted in Cole's first *View on the Arno*—in an oval format, which focuses attention on the setting sun in the very center of the image with radiating sunlight coming toward and embracing the viewer. Now in the Montclair Art Museum, this small canvas (17¾ × 25 inches) was first exhibited at the Accademia, probably in August 1831, where it was admired but not purchased by the grand duke.[6] Subsequently, the work was shipped home to New York, where it was no doubt included in Cole's one-person show of Italian pictures held in rented rooms at 1 Wall Street during the winter of 1832–33 and eventually sold to a "Mr. Wilkins."[7]

For a time after that first oval view of the Arno, Florentine landscapes were not on Cole's easel. In retrospect, it is easy to see why. After a stay in Rome and a side trip to Naples early in 1832, Cole had returned to Florence in June with so many commissions for Roman ruins, aqueducts in the Campagna, and Neapolitan scenes—all from wealthy Americans touring Europe—that he had no time for anything else. Then he received news that cholera had reached New York and that his parents were ill; he packed abruptly and sailed from Leghorn in October 1832. Nevertheless, as he eloquently explained to Dunlap in 1834, the siren call of Italy still echoed in his imagination:

Fig. 1. After J. M. W. Turner, engraved by E. Goodall, Florence, from *The Chiesa al Monte,* steel engraving published in *The Amulet* (London, 1831), photograph courtesy of Elwood C. Parry III

Fig. 2. Thomas Cole, *View of Florence* (also known as *View of Florence from S. Miniato*), 1837, oil on canvas, 39 × 63⅛ inches, The Cleveland Museum of Art, Ohio, Mr. and Mrs. William H. Marlatt Fund

Indeed, to speak of Italy is to recall the desire to return to it. And what I believe contributes to the enjoyment of being there, is the delightful freedom from the common cares and business of life—the vortex of politics and utilitarianism, that is for ever whirling at home. In Rome I was about three months, where I had a studio in the very house in which Claude lived. . . . Returned to Florence, I painted more pictures in three months than I have ever done in twice the time before or since. . . . O that I was there again, and in the same spirit![8]

To understand *Sunset on the Arno* more fully, it is important to look at the larger patterns of Cole's art production, contemporary patronage, and critical reactions to his work. In this regard, an insightful contemporary voice is well worth heeding. William Cullen Bryant, in his *Funeral Oration, Occasioned by the Death of Thomas Cole* (1848), commented on the considerable change Cole's style had undergone while the artist was in Italy, shifting from "a certain timid softness of manner" to a "free and robust boldness in imitating the effects of nature" that did not please every viewer:

I recollect that when his picture of the Fountain of Egeria, painted abroad, appeared in our exhibition, this change was generally remarked and was regretted by many, who pre-

ferred the gentle beauty of his earlier style, attained by repeated and careful touches, and who were half-disposed to wish that the artist had never seen the galleries of Europe.[9]

Bryant's assertion is convincingly contradicted by Cole's records of pictures painted and sold after his return from Italy. Both Italian and American subjects were being snapped up by local collectors. In fact, it is well known that Cole's homecoming exhibition of 1832–33 led directly to *The Course of Empire* (The New-York Historical Society) and other important commissions that kept him extremely busy through 1840. At the same time, possibly to appease "stay-at-home" critics, Cole made a regular practice of pairing an American view with a European scene. At the National Academy of Design spring exhibition in 1837, for instance, *View of Florence from S. Miniato* (Fig. 2) was accompanied by *View on the Catskill, Early Autumn* (The Metropolitan Museum of Art, New York)—both on canvases of exactly the same size.

On another level, a natural pairing of favorite home versus foreign scenes may have been a fundamental mode of thought in Cole's emotional universe in the 1830s. Once he had married Maria Bartow and settled at Cedar Grove outside the village of Catskill, autumnal evening views along Catskill Creek—with Catskill High Peak, Round Top, or North Mountain in the background—became standard fare, allowing the painter to juxtapose

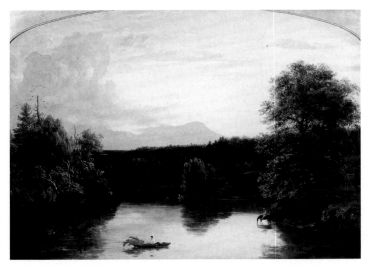

Fig. 3. Thomas Cole, *North Mountain and Catskill Creek* or *Sunset in the Catskills*, 1838, oil on canvas, mounted on wood panel, 26¾ × 36⅜ inches, Yale University Art Gallery, New Haven, Connecticut, gift of Anne Osborn Prentice

radiant autumn sunsets on Catskill Creek with enchanting summer sunsets on the Arno. Interestingly enough, the sunset view *North Mountain and Catskill Creek* (Fig. 3)[10] was originally painted with diagonal spandrels, cutting off all four corners, just like the larger sunset *View on the Arno* (Fig. 4), commissioned by

Horace Gray in July 1835. But this "octagonal" version was not finally finished and dated until May 23, 1837. Less than two weeks later, at the beginning of June, Cole went to Boston to deliver this canvas in person and to collect his money—not realizing how many replicas would be ordered in the months that followed.

The success of *View on the Arno* must have been intoxicating. In August 1837 Cole's friend and agent in Boston, Jonathan Mason, reported that "your picture sold to Mr. Gray took violent hold on my feelings. . . . I think you excell Turner in your light Blue skies and sunset scenes."[11] The fact that further orders came in despite the severe financial downturn caused by the Panic of 1837 overturns the conclusion, asserted in print in the later twentieth century, that American patrons wanted only American views.[12] Wealthy, highly educated, and well-traveled patrons, for whom European tours, often with their whole families, were customary events, obviously enjoyed Cole's reproductions of the beautiful Italian scenes they had admired themselves; whereas nativists, intent on promoting everything American, tended to prefer localized prose to sophisticated poetry. In the end, it seems, Cole was actually able to please both camps, but his smaller views naturally cost less than the larger ones and so were in greater demand. In any event, in a letter of January 31, 1838, to Asher B. Durand, Cole confessed that he had qualms

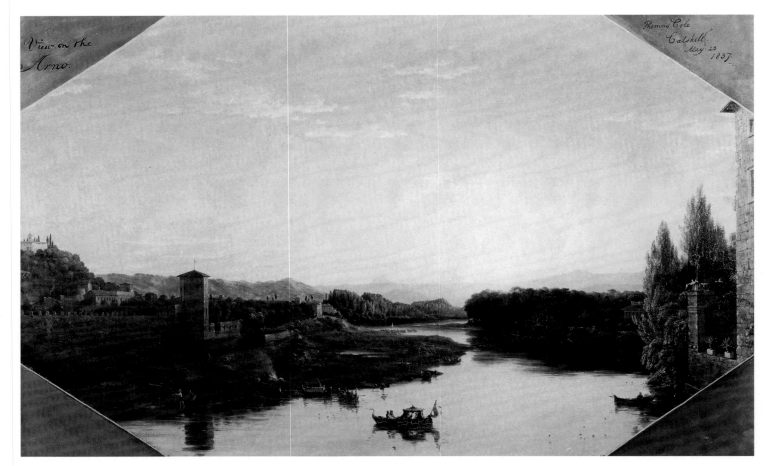

Fig. 4. Thomas Cole, *View on the Arno*, 1837, oil on canvas, 32¾ × 52½ inches, Collection of Mrs. Forbes S. Michie, on loan to the Worcester Art Museum, Massachusetts

about the latest "imported" product from his easel, which might oversaturate the market in Massachusetts: "I have finished a little view on the Arno for a gentleman [Jonathan Mason] in Boston. I am afraid the Arno will create a deluge in Boston: this is the third Arno for Boston."[13]

After Cole's untimely death in 1848, his biographer, Louis Legrand Noble, reported that the artist had done two more replicas of "the view down the Arno, at the close of day," that so captivated both Noble and the artist's audience.[14] Both were done on a larger scale than any of the four earlier versions. One of these, measuring 33 by 61 inches, was signed (but not dated) by Cole in his accustomed place—on the solid masonry next to paired agaves in pots (Fig. 5).[15] Lastly, according to Noble, the other work (Cat. 1), "one of these later sunsets on the Arno— unfinished in the foreground, yet very beautiful even in its incompleteness—is still in the possession of his family"[16]—and that remains true to this day.

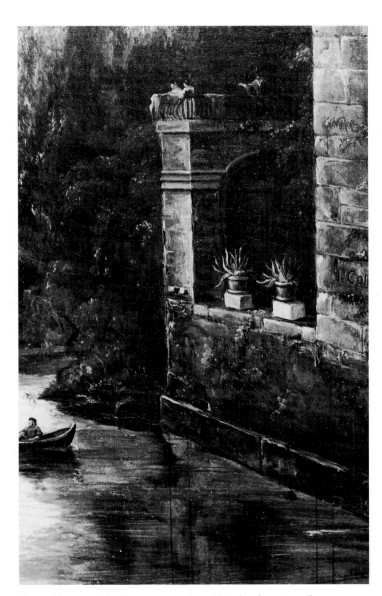

Fig. 5. Thomas Cole, *Sunset on the Arno* (detail), after 1837, oil on canvas, 32 × 61 inches, private collection

NOTES

1. William Dunlap, *History of the Rise and Progress of the Arts of Design*, 2 vols. (New York, 1834), vol. 2, p. 361. Cole's personal copy of Dunlap's book— with fascinating marginal annotations revealing the degree of his distress— is in the Watkinson Library, Trinity College, Hartford, Connecticut.

2. Dunlap, *History*, vol. 2, p. 363. The actual letters exchanged between Cole and Dunlap in 1834 are among the Thomas Cole Papers, New York State Library, Albany (hereafter NYSL).

3. Thomas Cole Sketchbook No. 5, leaves 4 and 5, The Detroit Institute of Arts, 39.562. The site from which Turner and Cole made their drawings was reconstructed in the 1860s as the Piazzale Michelangelo, which, creating an inviting panorama platform and tourist attraction, added to the locale's appeal.

4. See Cole's Sketchbook No. 5, leaves 9, 20, and 21. It should also be mentioned that, in addition to studying the human figure at the Accademia in Florence, Cole made at least two oil sketches—both featuring poplar trees—that appear to be views from a window looking away from urban Florence toward the open countryside. *View of Poplars* was with Albany Gallery, Albany, New York, in December 1994. More interesting still is *View from the Artist's Window, Florence* (private collection), which is inscribed on the back in Cole's handwriting: "Florence Sept 25, 1831 / From my Window— Morning, Wind Blowing. Objects not correct—merely colour—Painted in Distemper Ground of Gesso and Glue with a little Honey—Vehicle Copal Varnish and a little oil—Colours ground in oil."

5. Among the Cole Papers, NYSL, is an extensive list, "Commissions for pictures—July 1835." The first entry on this list reads: "For Mr. H. Gray of Boston a view on the Arno the Sketch of which I took purposely from the house in which Mr. G lived in Florence—Size 4 feet or 4.6 inches." (See Fig. 4, which measures 4 feet 4½ inches wide.) This important connection was first identified by Howard Merritt in his exhibition catalogue, *Thomas Cole* (Rochester, N.Y.: Memorial Art Gallery, 1969), no. 37, p. 33.

6. See Dunlap, *History*, vol. 2, p. 363.

7. Thomas Cole to Robert Gilmor, Jr., Florence, January 29, 1832, Cole Papers, NYSL. Also see Louis Legrand Noble, *The Life and Works of Thomas Cole*, ed. Elliot S. Vesell (Cambridge, Mass.: The Belknap Press of Harvard University Press, 1964), p. 102: "I have sent, with the large picture to New York, a small one—a Sunset on the Arno: it is a simple effect. I should wish you to see it." The key phrase in the original letter reads: "it is a simple picture" with "picture" crossed out and "effect" inserted. By "simple picture" Cole probably meant "direct" and "straightforward," "without artifice." Whereas the large painting, *A Wild Scene* (The Baltimore Museum of Art), was intended to repay his debt to Gilmor of several hundred dollars, the artist wanted the patron to "see" the Arno scene—just in case he might want to buy it. The sale to Mr. Wilkins of New York is indicated in Cole's "List of Pictures painted by me," under the subheading "Painted in Italy." Cole Papers, NYSL. Machine copy in the New-York Historical Society Library: "Cole, Thos. / UNDTD / NYSL / List of Pictures / A/280."

8. Dunlap, *History*, vol. 2, pp. 363–64.

9. Bryant, *A Funeral Oration, Occasioned by the Death of Thomas Cole, Delivered before the National Academy of Design, New-York, May 4, 1848* (New York, 1848), p. 21. The particular picture Bryant referred to, *Fountain of Egeria*, was actually one of two acquired, according to Cole's "List of Pictures painted by me," by H. W. Field, New York. While the *Fountain of Egeria* remains unlocated, the other work, *Palazzo della Regina Giovanna, Naples*, hangs above the fireplace in the rear parlor of the John Jay Homestead in Katonah, New York. An article by the researcher Louise V. North, "Discovered in Homestead Collection: A 'Lost' Thomas Cole Landscape Surfaces at John Jay," *Friends of John Jay Homestead Newsletter* 22 (Winter 1994), pp. 4–5, demonstrates that Hickson Woolman Field's daughter, Eleanor, married John Jay II, son of the first Chief Justice of the Supreme Court, and so helps to explain the painting's provenance and present location.

10. See David Steinberg, "Thomas Cole's *North Mountain and Catskill Creek*," *Yale University Art Gallery Bulletin* 39 (Winter 1986), pp. 24–29.

11. Jonathan Mason to Thomas Cole, August 29, 1837, Cole Papers, NYSL.

12. See Barbara Novak, "Thomas Cole: The Dilemma of the Real and the Ideal," in *American Painting of the Nineteenth Century: Realism, Idealism, and the American Experience,* (1969; 2d ed., New York: Harper & Row, 1979), pp. 61–79.

13. Thomas Cole to Asher B. Durand, Catskill, January 31, 1838, Cole Papers, NYSL. Quoted in Noble, *Thomas Cole,* p. 102. If Gray's octagonal view (approx. 32 × 52 inches) was the first view of the Arno sent to Boston, then the replica of it (32 × 51½ inches), now in the Thyssen-Bornemisza Collection, Lugano, Switzerland, may have been the second. The smaller version for Jonathan Mason thus must be *View on the Arno* (oil on panel, 17 × 25½ inches) now in the Shelburne Museum, Shelburne, Vermont.

14. Noble's eloquent description of Cole's continuing commitment to his favorite view on the Arno reads as follows: "The view down the Arno, at the close of day, was one to which Cole gave long and frequent contemplation. It took his spirit captive; and his picture of it (though attractive to Florentines themselves, and really, as Bryant calls it, 'a fine painting, with the river gleaming in the middleground, the dark woods of the Cascine on the right, and above, in the distance, the mountain summits half dissolved in the vapoury splendour which belongs to an Italian sunset') was, he felt, but a dim reflection of the living beauty, which, as time ripened his powers, and gave his greater mastery of the pencil [paintbrush], he might hope more nearly to approach"; *Thomas Cole,* p. 102.

15. This painting is recorded in John Paul Driscoll, *All That Is Glorious around Us: Paintings from the Hudson River School,* exh. cat. (University Park: The Pennsylvania State University Museum of Art, 1981), pp. 58–59.

16. Noble, *Thomas Cole,* pp. 102–3.

PROVENANCE

This painting was listed in the inventory of paintings in Cole's possession at the time of his death. It hung in the artist's studio or in the main house at 218 Spring Street, Catskill, New York (known as Cedar Grove), until the buildings were sold in 1979 to raise funds to establish a museum. It remains to this day in the collection of the artist's descendants.

EXHIBITED

Kennedy Galleries, Inc., New York, *Paintings by Thomas Cole, N.A., from the Artist's Studio, Catskill, New York,* November 24–December 31, 1964, no. 23, (p. 11 illus.); Kennedy Galleries, Inc., New York, *The American Artist Abroad,* September 17–October 5, 1968, no. 143 (pp. 127, 134–35 illus.); Virginia Steele Scott Gallery at the Huntington Library, Art Collections, and Botanical Gardens, San Marino, California, 1983–87 (exhibited with the permanent collection); The High Museum of Art, Atlanta, Georgia, April 1987–90 (on loan); The Center for the Arts, Vero Beach, Florida, *Collectors Choice,* November 23, 1990–January 13, 1991, no. 60; The Hudson River Museum, Yonkers, New York, 1991–93.

LITERATURE

Louis Legrand Noble, *The Life and Works of Thomas Cole* (1853; reprint, Cambridge, Mass.: The Belknap Press of Harvard University Press, 1964), p. 102; "very beautiful . . . it is still in the possession of his family"; *The Kennedy Quarterly* 8 (September 1968), pp. 134 (no. 143) illus., 135; Wayne Craven, "Thomas Cole and Italy," *Antiques* 114 (November 1978), pp. 1016 (incorrectly identified as the painting Cole exhibited at the Academy of Saint Luke in Florence, 1832), 1018 illus.

Cole painted five other known versions of this composition. These include two small works: *View on the Arno* of 1831–32 (oil on canvas, 17¾ × 25 inches, oval, Montclair Art Museum, New Jersey) and *View on the Arno* of 1837 (oil on panel, 17 × 25½ inches, Shelburne Museum, Vermont. Three larger works are approximately the same size as *Sunset on the Arno* (cat. 1): *Sunset on the Arno* of 1832 (oil on canvas, 33 × 61 inches, private collection); *View on the Arno* of 1837 (oil on canvas, 33¼ × 53¼ inches, hexagonal, Worcester Art Museum, Massachusetts, gift of Martha Esty Michie); and *View on the Arno* of ca. 1838 (oil on canvas, 32 × 51½ inches, The Thyssen-Bornemisza Collection, Lugano-Castagnola, Switzerland).

A related pencil study is in the Cole Sketchbook No. 15, leaf 102, and endsheet (The Detroit Institute of Arts).

Fitz Hugh Lane (1804–1865)

2. *A Storm, Breaking Away, Vessel Slipping Her Cable,* 1858

Oil on canvas

23½ × 35½ inches

Signed and dated lower right: *F. H. Lane 1858*

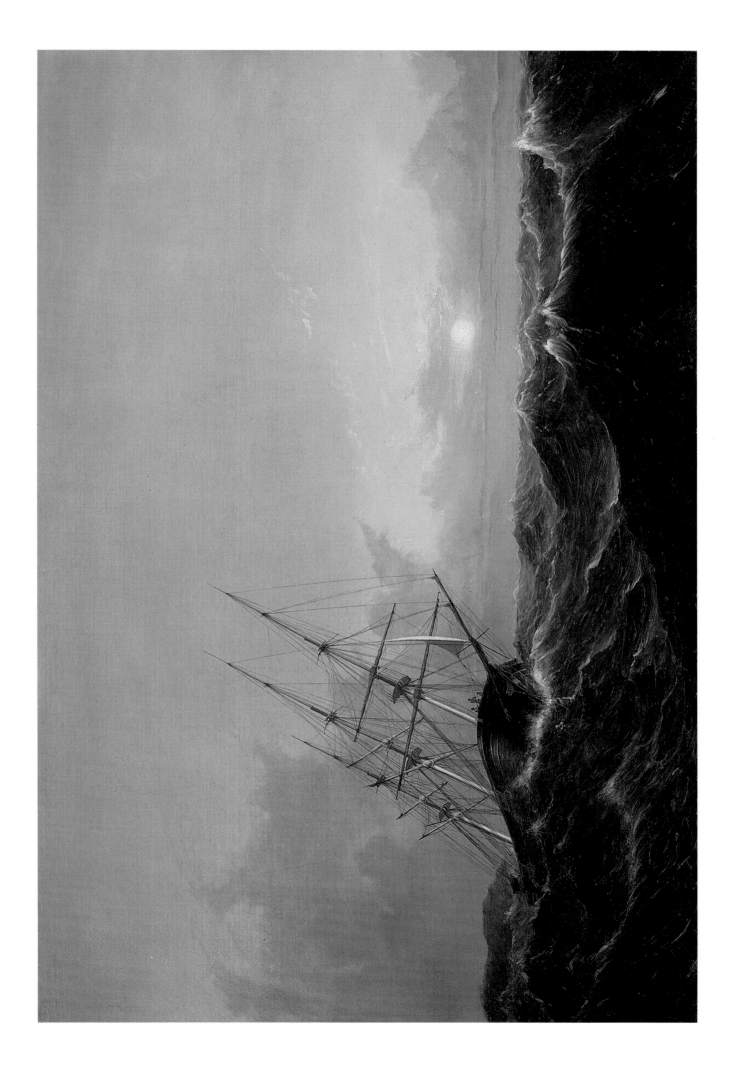
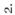

Fitz Hugh Lane: *A Storm, Breaking Away, Vessel Slipping Her Cable*, 1858

by Erik A. R. Ronnberg, Jr.

A PREEMINENT MARINE PAINTER, Fitz Hugh Lane maintains a pivotal place in the history of nineteenth-century American art. He was a creator of innovative seascapes as well as one of the first American painters to embrace the aesthetic known today as Luminism, a style that emphasized poetic, light-filled views of land and water painted in a meticulous realist manner.[1]

Lane's paintings of ships in stormy seas, under sail and at anchor, form a small and not well studied aspect of his oeuvre. They are so unlike his tranquil harbor views with their delicate atmospheric effects, or his ship portraits that chafe at every convention of the formulaic genre, that it is difficult to think of them as works by the same artist. The melodrama of storm-tossed ships amid mountainous dark seas and wild skies is hard to reconcile with the still water, delicate colors, and exquisite play of light and reflections in the best-known canvases of this great American Luminist.

One tendency among commentators has been to dismiss them as obligatory works—painted to satisfy insistent customers and seafaring acquaintances who had witnessed such conditions. Some were painted for shipowners who may have felt that these views promoted business by proclaiming the seaworthiness of their vessels and competence of their crews. So overwhelming are the depicted sea and weather conditions that one wonders if accuracy has been sacrificed to dramatics. Could Lane, whose physical handicaps prevented him from experiencing such storms as a mariner, have gained the practical knowledge to depict a vessel in heavy weather, correctly handled in all aspects of seamanship? The answer seems to be

yes, that through reading books on seamanship and from discussion with sailor acquaintances, Lane became proficient at depicting purposeful crew activity. His ships are invariably firmly under control and well handled in every respect.[2]

Two of the larger images in this category depict a ship at anchor off a lee shore at dawn, with the sun shining through the breaking stormclouds. One, titled *A Rough Sea* (Fig. 6), is unsigned, undated, and now owned by the Cape Ann Historical Association. In his research on its provenance, Alfred Mansfield Brooks found that Lane painted the picture for Obadiah Woodbury, a Gloucester merchant and prominent shipowner.[3] This image is probably better known from Mary Blood Mellen's copy entitled *A Storm, Breaking Away, Vessel Slipping Her Cable* (Fig. 7).[4]

The title of the Mellen copy is puzzling on several counts: the ship is riding safely with both her anchors out, and any attempt to "slip her cable" in her depicted state of readiness would have ended in disaster. There is no crew activity to indicate that the ship is ready to sail immediately on letting the cable slip. Closer inspection reveals that the square sails are furled tightly on the lower- and the topsail yards, which have been braced sharply at opposing angles to lessen wind resistance. The topgallant and royal yards have been sent down and stowed, while the topgallant masts themselves have been "housed" (partially lowered but not removed) also to reduce windage (wind resistance). In all, this is a picture of competent ship handling with all the safety precautions taken and no avoidable situation left to chance.

The second image (Cat. 2), signed by Lane and dated 1858, was exhibited at the thirty-fifth annual exhibition of the Pennsylvania Academy of the Fine Arts, Philadelphia, in April 1858 with the same title that Mellen's painting now bears. Clearly the Mellen work was later given an identical title to Lane's in the mistaken belief that her painting was a copy of his.[5] However, the two works are quite different.

In Lane's *Storm, Breaking Away, Vessel Slipping Her Cable*, the ship is riding to only one anchor instead of two, and a buoy and line have been hitched to the cable. The latter practice was often done when a ship slipped her cable; thus marked by the buoy, the cable and anchor could be salvaged at a later time.[6] Slipping the cable was an emergency measure, which called for smart seamanship to get the ship under sail and on a safe course as soon as the cable had run out.

The ship is also riding to her starboard anchor. Her port anchor and cable—her heaviest ground tackle—are missing, probably having parted (broken) at the height of the storm. This seemingly minor technicality would have had great

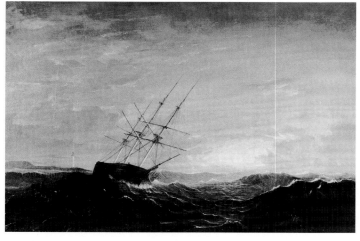

Fig. 6. Fitz Hugh Lane, *A Rough Sea*, ca. 1860, oil on canvas, 23½ × 35½ inches, Cape Ann Historical Association, Gloucester, Massachusetts, Gift of Professor and Mrs. Alfred Mansfield Brooks

Fig. 7. Mary Blood Mellen, *A Storm, Breaking Away, Vessel Slipping Her Cable*, 1868, oil on canvas, 23½ × 25½ inches, private collection, photograph courtesy Spanierman Gallery, LLC, New York

significance to any competent sailor of the period and lends additional drama to the vessel's situation.[7]

If Lane had intended to show the vessel slipping her cable to get under way, he would have shown the square topsails loosed (unfurled) and ready to set. This would have been attended by much crew activity in the rigging. Contrary to this, the sails are snugly furled except for one jib, which would hardly have provided the needed driving power, even in this tempest. The ship is therefore not quite ready to slip her cable; further procedures are necessary before she can do so.[8]

A more complete explanation of the vessel's situation is that she is riding to anchor and the tidal current has changed, forcing her to shift her position in a maneuver called "tending." Tending an anchored ship meant keeping the anchor cable taut because the vessel could "trip" an anchor, loosening its hold on the bottom, or the loose cable could "foul" (wrap around) the anchor's exposed fluke, dislodging the buried fluke. A tripped or fouled anchor would lose its holding ability under any tension, imperiling the vessel. Preventing such accidents and maintaining cable tension meant that the ship had to be steered in an arc whenever tidal currents or winds shifted its position. In some cases, this was done by actually sailing the

ship around the anchor, setting one or two jibs to provide motive power when the wind was advantageous.[9]

The relative directions of tidal currents and winds dictated the evolutions of tending a ship. Usually, tides were stronger than winds, so an anchored vessel would swing to face the current. When wind and current directions opposed each other, the current was called a "windward tide"; when moving in the same direction, it was a "leeward tide." A ship anchored in a windward tide that was turning would then become a ship in a leeward tide. The ship then had to swing in an arc to face the new current direction; doing so was called "tending to leeward." If swinging to a current changing from a leeward tide to a windward tide, the vessel would be "tending to windward."[10]

Lane's painting shows the ship tending to leeward. Under a single jib, she has worked her way clockwise around her anchor and she will soon swing her bow into the wind and current. Her yards are braced sharply so that if forced to slip her cable and get under way, the topsails can be set to turn the vessel quickly so she can be steered safely past the land and out into the safety of open water.

In sum, Lane's canvas portrays a ship anchored on a lee shore the morning after a severe gale. Her best anchor and

cable have parted; the remaining ground tackle is ready to be slipped. The tide has turned, and she is tending to leeward under her jib. Spars, rigging, and sails are in a state of readiness so working sail can be set at any moment. The greatest danger has passed, but the drama is not yet over, and it will take first-class seamanship to get this ship out of her dangerous anchorage and into open water. A mariner of the period, and no doubt Obadiah Woodbury himself, would have appreciated the situation Lane has portrayed and found satisfaction in the measures depicted to save the ship.

Painted with a skillful orchestration of color, outstanding draftsmanship, crisp details, and a careful balance of lights and darks, *A Storm, Breaking Away, Vessel Slipping Her Cable* is a superb example of Lane's highly personal version of Luminism. At the same time, the painting's deftly constructed drama of seafaring will reward those with the knowledge and curiosity to explore the complexities of nineteenth-century seamanship.

NOTES

1. Exponents of Luminism included Frederic Edwin Church, John F. Kensett, Martin Johnson Heade, and Sanford R. Gifford. For a discussion of the style and its practitioners, see John Wilmerding, ed., *American Light: The Luminist Movement, 1850–1875*, exh. cat. (Washington, D.C.: National Gallery of Art, 1980).

2. Erik A. R. Ronnberg, Jr., "Imagery and Types of Vessels," in John Wilmerding et al., *Paintings by Fitz Hugh Lane*, exh. cat. (Washington, D.C.: National Gallery of Art, 1988), pp. 68–70.

3. *Paintings and Drawings by Fitz Hugh Lane, Preserved in the Collections of the Cape Ann Historical Association* (Gloucester, Mass.: Cape Ann Historical Association, 1974), no. 60. Information on Obadiah Woodbury may be found in the records of the Cape Ann Historical Association.

4. Michael Moses, "Mary Blood Mellen and Fitz Hugh Lane," *Antiques* 140 (November 1991), pp. 829, 836.

5. Moses, "Mary Blood Mellen and Fitz Hugh Lane," p. 836.

6. John H. Harland, *Seamanship in the Age of Sail* (London: Conway Maritime Press, 1984), pp. 276, 277.

7. Harland, *Seamanship*, p. 237.

8. John Todd and W. B. Whall, *Practical Seamanship for Use in the Merchant Service*, 5th ed. (London: G. Philip & Son, 1904), p. 79.

9. Harland, *Seamanship*, p. 247.

10. Darcy Lever, *The Young Sea Officer's Sheet Anchor*, 2d ed. (London, 1819; reprint, New York: Edward W. Sweetman, 1955), pp. 101, 102.

PROVENANCE

J. S. Earle, 1858; [art market, Massachusetts, in 1976]; to private collection, 1976.

EXHIBITED

Pennsylvania Academy of the Fine Arts, Philadelphia, *Thirty-fifth Annual Exhibition*, April 1858, no. 317 (as *A Storm, Breaking Away, Vessel Slipping Her Cable*; p. 18, incorrectly as lent by Mr. Parker); Edward J. Brickhouse Nineteenth-Century Gallery, The Chrysler Museum of Art, Norfolk, Virginia, July 20, 1992 – April 21, 1997.

LITERATURE

Michael Moses, "Mary Blood Mellen and Fitz Hugh Lane," *Antiques* 140 (November 1991), pp. 829, 836, color pl. XVIII.

Sanford Robinson Gifford (1823–1880)

3. *Autumn in the Catskills,* 1861

Oil on canvas

14¼ × 24 inches

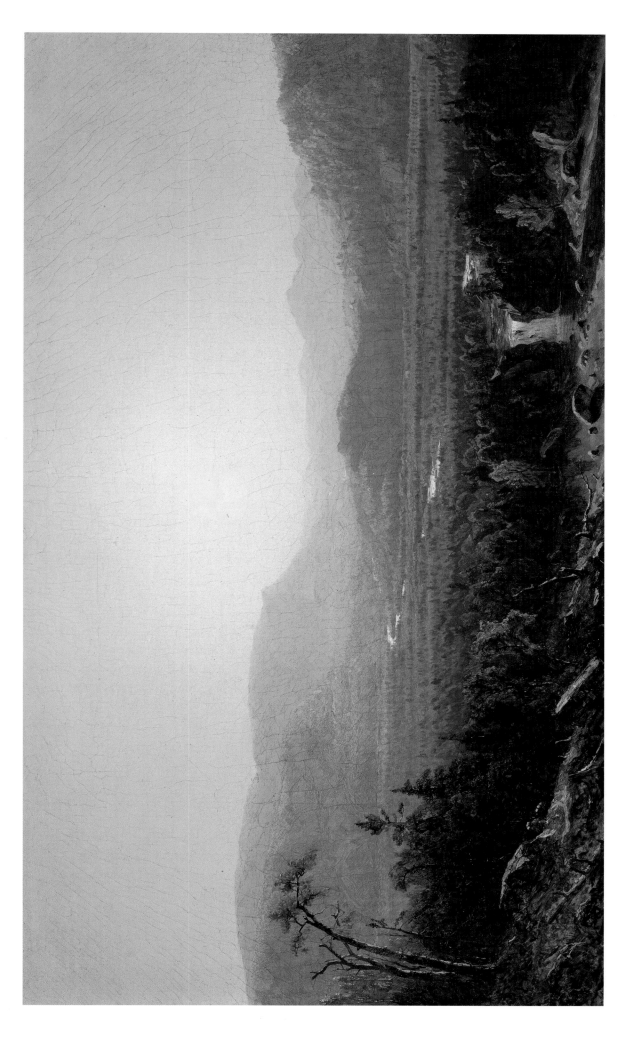

3.

Sanford Robinson Gifford: *Autumn in the Catskills*, 1861

by Carol Lowrey

ALEADING EXPONENT of Luminism, Sanford Gifford combined his interest in depicting American scenery with his concern for rendering natural phenomena.[1] Like other artists associated with the Hudson River School, such as John F. Kensett and Martin Johnson Heade, Gifford eschewed the monumental, grandiose landscapes favored by artists such as Frederic Church in favor of more intimate compositions characterized by an emphasis on light and atmosphere. His penchant for a hazy, opalescent luminosity transformed his paintings from purely realist transcriptions into the realm of poetry. Gifford was one of the most popular and beloved artists of his day, and his landscapes were well received by both critics and the public. His many admirers included the art historian Henry Tuckerman, who praised the artist's ability to evoke "an harmonious effect and impression" and noted his "true eye for atmospheric effects," while his friend and fellow artist John Ferguson Weir hailed him as a painter who "loved the light."[2]

Gifford painted in the Berkshire and Adirondack mountains, as well as in New Hampshire, Vermont, and New Jersey. However, his most vital source of inspiration came from the Catskill Mountains of upstate New York, a region intimately associated with the Hudson River School tradition.[3] To be sure, Gifford had a strong and very personal attachment to the Catskills: the son of an affluent foundry owner, he grew up in Hudson, New York, located across the Hudson River from the town of Catskill. As a youth, he made hiking trips throughout the area, often climbing Mount Merino to observe the river and surrounding mountains, and these activities nurtured his devotion to and familiarity with his immediate environment. After abandoning portraiture for landscape painting in 1846, Gifford made regular sketching trips throughout the Catskills. So vital was the area to his artistic development and iconography that a later eulogy noted that, although he was actually born in Saratoga County, "As an artist he was born in the Catskill Mountains. He loved them as he loved his mother."[4]

Like many Hudson River School painters, among them Thomas Cole and Asher B. Durand, Gifford was drawn to Kaaterskill Clove, an immense gorge located in the midst of the Catskills near the villages of Tannersville and Palenville (Fig. 8). The artist painted in the clove and its environs on numerous occasions, beginning in 1845, but he was especially active there throughout the early to mid-1860s, during which time he produced some of his finest views of the clove, capturing its distinctive topography and vaporous ambience in such works as *View near Kaaterskill Clove* (Fig. 9).

Gifford's *Autumn in the Catskills* (Cat. 3), from 1861, is unique in the artist's oeuvre in that it represents a panorama of the clove. Indeed, the image is an idealized view painted from just south of the town of Catskill, looking west across the Kiskatom Flats floodplain toward the opening to Kaaterskill Clove with High Peak, South Mountain, and Round Top beyond and Hunter Mountain in the distance.[5] Gifford's vista includes the shimmering waters of Kaaterskill Creek, which flows southeast out of the clove before turning north toward Catskill and finally dropping in a waterfall in the right foreground.[6] The vastness of the terrain is accentuated by the inclusion of a small figure in the lower left, a compositional device that appears in many works from the 1850s and 1860s.

Autumn in the Catskills exemplifies Gifford's distinctive approach to Luminism. The greater part of the view is bathed in the mellow rays of late afternoon sunlight—a softly diffused luminosity that imbues the scene with feelings of calm and serenity. In typical fashion, his mountains are enveloped in a misty, atmospheric haze that reflects his belief that "the real important matter is not the natural object itself, but the veil of medium through which we see it."[7] Gifford achieves the effects of aerial perspective through both technique and subtle gradations of tone. The controlled brushwork used to describe the landscape elements in the foreground gives way to a more painterly approach in rendering the distant terrain and mountains, and a smooth, uniform application in the sky. Similarly, the dark greens, golds, russets, and browns in the foreground are offset by the iridescent oranges, blues, and mauves that

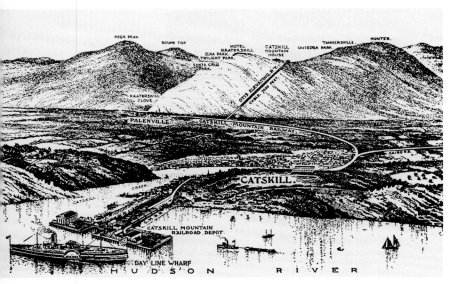

Fig. 8. Catskill Region Including the Kaaterskill Clove, from Walton van Loan, *Van Loan's Catskill Mountain Guide* (1879; reprint, New York: Dudley Press, 1909), p. 6

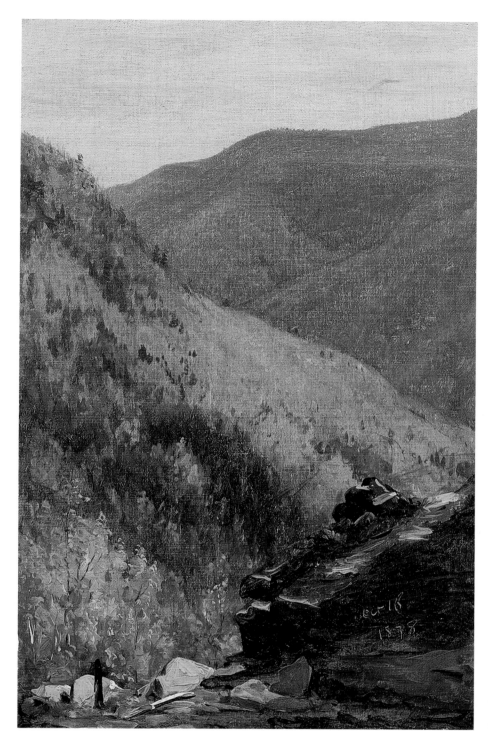

Fig. 9. Sanford R. Gifford, *View near Kaaterskill Clove*, 1878, oil on canvas, 15 × 9½ inches, Spanierman Gallery, LLC, New York

describe the sunlit fall foliage in the middle ground. Lighter tints of the same colors appear in the distant hills, enhancing the sensation of distance and depth and further contributing to the evanescent quality of the image. Gifford's expressive palette—the legacy of his contact with the paintings of Joseph Mallord William Turner during a trip to England in 1855—includes deftly applied touches of white and gray used to depict the reflections of light on the surface of the water, giving it the appearance of a silvery ribbon winding its way through the countryside.

Autumn in the Catskills found a ready buyer: early in 1861 it was purchased by James L. Claghorn, an important Phila-delphia collector and then-president of the Pennsylvania Academy of the Fine Arts. That such a discerning connoisseur would be attracted to the painting is not surprising, for it attests to Gifford's reputation as a leading American landscape painter of the nineteenth century, underscoring his sensitivity to the nuances of color, light, and atmosphere, as well as his ability to capture the moods of nature. Described by one commentator as a "luscious, lotus-eating land of faëry," the canvas bears personal meaning too, for Gifford also pays homage to the beauty and grandeur of the Hudson River Valley—his home territory and primary painting ground throughout his career.[8]

NOTES

1. Luminism flourished from the 1850s to about 1880. The term was coined in 1954 by John I. H. Baur in his article "American Luminism," *Perspectives USA* (Autumn 1954), pp. 90–98. For further reading, see John Wilmerding, introduction, *American Light: The Luminist Movement, 1850–1875*, exh. cat. (Washington, D.C.: National Gallery of Art, 1980), and John K. Howat, introduction, *American Paradise: The World of the Hudson River School*, exh. cat. (New York: The Metropolitan Museum of Art, 1987).

2. Henry T. Tuckerman, *Book of the Artists: American Artist Life* (1867; reprint, New York: James F. Carr, 1967), pp. 524, 527; J. Ferguson Weir quoted in *Gifford Memorial Meeting of the Century* (New York: Century Association, 1880), p. 23. For Gifford's life and career, see Ila Weiss, *Poetic Landscape: The Art and Experience of Sanford R. Gifford* (Newark: University of Delaware Press, 1987), and by the same author, *Sanford Robinson Gifford (1823–1880)* (New York: Garland Publishing, 1977).

3. For the importance of the Catskill region in nineteenth-century American art and culture, see Kenneth Myers, *The Catskills: Painters, Writers, and Tourists in the Mountains, 1820–1895*, exh. cat. (Yonkers, N.Y.: Hudson River Museum, 1987).

4. Quoted in *Gifford Memorial Meeting of the Century*, p. 43.

5. Information on the painting's location was provided in a letter from Ila Weiss, October 12, 1995, Spanierman Gallery, LLC, New York, Archives.

6. Weiss has suggested that Gifford may have sketched the view during the autumn of 1860, when he explored the Hudson Highlands, to the south, with a fellow painter, Jervis McEntee. See letter from Ila Weiss, October 12, 1995.

7. See "How One Landscape-Painter Paints," *Art Journal* 3 (1877), quoted in Nicolai Cikovsky, Jr., *Sanford Robinson Gifford, 1823–1880*, exh. cat. (Austin: University of Texas Art Museum, 1970), p. 16.

8. "Private Art Collections of Phila. / I.—Mr. James L. Claghorn's Gallery," *Lippincott's Magazine* 8 (April 1872), p. 437. Weiss has pointed out that in *The Gifford Memorial Catalogue*, "based upon notes left by Mr. Gifford" (now lost), the painting was listed as number 217, *A Catskill Study*, 14 × 24 inches, sold to J. L. Claghorn of Philadelphia in 1861, with the present owner unknown. In view of its size, and the fact that the artist designated the work as a "study," she feels that the painting was conceived as a prelude to a larger exhibition piece for which there is no evidence, and which was probably never executed. Information courtesy of Ila Weiss.

PROVENANCE

The artist, 1861; to James L. Claghorn, Philadelphia (1817–1884; founding member of the American Art Union, president, School of Design for Women, Philadelphia [now Moore College of Art], and president, Pennsylvania Academy of the Fine Arts, Philadelphia), 1861–77; to [sale, Kurtz Gallery, New York, Robert Somerville, Auctioneer, *Valuable Paintings, the Private Collection of Mr. James L. Claghorn, of Philadelphia, Comprising well-chosen examples of the various schools of Modern Art, by French, German, American, Roman, and Spanish Masters*, April 18, 1877, no. 24]; Mrs. and Mrs. Benton Case, Jr., Minneapolis, 1965–87; to [art market, New York, 1987]; to private collection, Michigan, 1987; Mr. and Mrs. Randolph J. Agley, 1989; to [Sotheby's, New York, November 29, 1995, lot 104].

EXHIBITED

Pennsylvania Academy of the Fine Arts, Philadelphia, *Thirty-eighth Annual Exhibition*, 1861, no. 528 (as *In the Catskills*, by J. [*sic*] R. Gifford, lent by James L. Claghorn); United States Christian Commission, Academy of the Fine Arts, Philadelphia, *Exhibition of a Private Collection*, 1864, no. 184 (p. 19, as by J. [*sic*] R. Gifford); Philadelphia Union League, *Third Art Reception*, October 28–31, 1873, no. 127 (p. 7); Minneapolis Institute of Art, *Fiftieth Anniversary Exhibition, 1915–1965*, November 4, 1965–January 2, 1966, checklist (as *Far Western Landscape*).

LITERATURE

Henry T. Tuckerman, *Book of the Artists: American Artist Life* (New York, 1867; reprint, New York: James F. Carr, 1967), p. 630; *Catalogue of Paintings Belonging to James L. Claghorn, Philadelphia* [1869], p. 5 (no. 78); "Art in Philadelphia / Mr. James L. Claghorn's Private Gallery of Oil Paintings— a General Description," *Philadelphia Inquirer*, November 1876; "More Paintings / The Claghorn Collection," *New York Commercial Advertiser*, March 9, 1877, p. 4; "The Claghorn Collection," *Chicago Tribune*, March 25, 1877; "Private Art Collections of Phila. / I.—Mr. James L. Claghorn's Gallery," *Lippincott's Magazine* (April 1872), pp. 437, 442: "Gifford, in a Catskill view, depicts dreamily a luscious, lotus-eating land of faëry"; "Mr. Claghorn's Paintings," *Cincinnati, Ohio*, April 6, 1877 (unidentified title, clipping, James L. Claghorn Papers, "Scrapbook," Archives of American Art, Smithsonian Institution, Washington, D.C., p. 53, reel 4131; "The Claghorn Collection / A Description of the Paintings Now on View at the Kurtz Gallery," *New York Daily Graphic* (April 9, 1877), p. 6; "A Great Exhibition / The Claghorn Paintings" *New York Commercial Advertiser*, April 10, 1877, p. 1: "Of S. R. Gifford's work there is one of his golden-toned sunsets"; "The Claghorn Collection of Paintings" *New York Times*, April 14, 1877, p. 3, no. 24: "has freshness and boldness which his late work sadly wants"; "The Claghorn Gallery / Sale Last Evening—a Large Attendance and Good Prices," *New York Commercial Advertiser*, April 19, 1877, p. 3; "The Claghorn Collection / First Night's Sale," *New York Times*, April 19, 1877, p. 8; The Metropolitan Museum of Art, *A Memorial Catalogue of the Paintings of Sanford Robinson Gifford, N.A.* (New York, 1881), p. 22, (no. 217, as "*A Catskill Study* . . . to J. L. Claghorn, Philadelphia, Pa; present owner unknown").

Chauncey Bradley Ives (1810–1894)

4. *Undine Rising from the Waters*, 1880

White marble
Height: 77 inches
Inscribed fillet edge of base, proper right: *C. B. Ives. Fecit. Romae.*

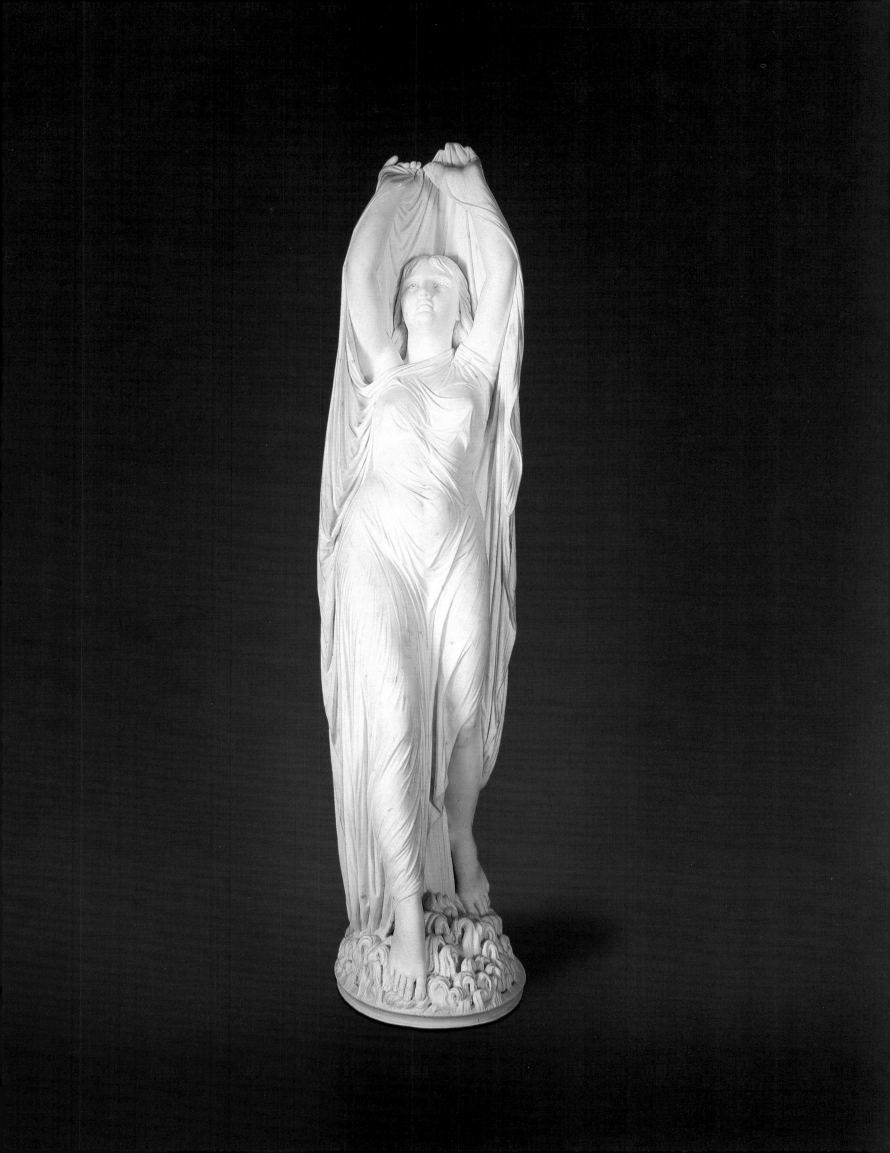

Chauncey Bradley Ives: *Undine Rising from the Waters*, 1880

by H. Nichols B. Clark

CHAUNCEY BRADLEY IVES played a significant role in popularizing sculpture in America, and versatility was key to his success.[1] The sculptor imbued naturalism and flattery into his portrait busts, endowed his ideal pieces with an appropriate dignity, and infused his genre pieces with an appealing sentimentality.

Born into a farm family, near New Haven, Connecticut, Ives's frail health and preference for art over farming prompted his father to apprentice him to a wood-carver in New Haven. Securing a solid foundation in the art of carving by 1837, Ives established an independent studio in Boston and quickly achieved modest success. Amid the promise of this emerging career loomed his uncertain health; the sculptor's vulnerable constitution alarmed a local doctor, who recommended he relocate to a more temperate climate.

Initially, Ives settled in Florence, Italy, in 1844. The presence of Horatio Greenough as well as Lorenzo Bartolini and his doctrine of naturalism may have attracted Ives to this Tuscan city rather than to Rome.[2] A milestone came in 1847 when Ives completed his first full-length ideal piece, *Boy and Dove* (The Chrysler Museum, Norfolk, Va.), which inaugurated his series of appealing images of children. This achievement, coupled with steady demand for portraits, enabled Ives to commence another ambitious full-length piece in 1850, the first version of *Pandora* (Fig. 10), which he modeled in Florence but did not translate into marble until after he moved to Rome late in 1851.[3]

Ives's reasons for moving to Rome are not clear, but his growing commitment to ideal pieces provided ample incentive to seek a more sympathetic working environment. Rome became his permanent home, although he made numerous return visits to America. The sculptor occupied himself with additional full-length works, such as *Undine Receiving Her Soul* (Fig. 11), ordered by the influential patron from New York Marshall O. Roberts and created in 1859. A wave of popularity and prosperity carried Ives into the next decade, and his output assumed a well-established pattern, reflecting the sculptor's devotion to the purity of the Neoclassical canon.

While Ives established his reputation with works taken from Greek mythology and romantic literature, he inevitably embraced a theme central to nineteenth-century ideal sculpture: woman's nature and woman's destiny, especially as informed by her vulnerability.[4] This fragility was reinforced by the predilection to render the female nude, a practice that underscored its status as the preeminent canon for beauty. Hiram Powers, through his clever marketing of *The Greek Slave* (Fig. 12), gained acceptance for the display of the nude female form when the moral circumstances warranted it. Ives was one

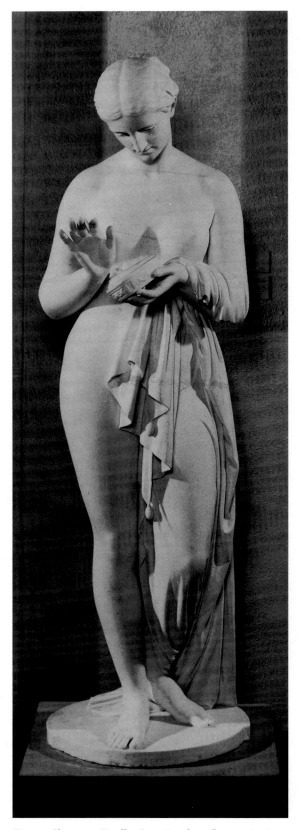

Fig. 10. Chauncey Bradley Ives, *Pandora* (first version), modeled 1851, carved 1854, marble, 64¼ inches high, Virginia Museum of Fine Arts, Richmond, Gift of Mrs. William A. Willingham

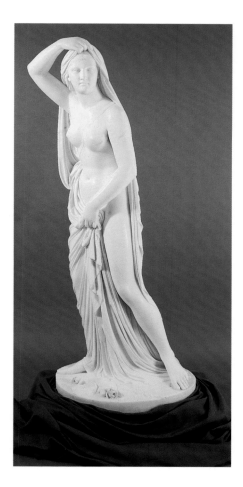

Fig. 11. Chauncey Bradley Ives, *Undine Receiving Her Soul*, modeled 1858, carved 1861, marble, 63 inches high, Spanierman Gallery, LLC, New York

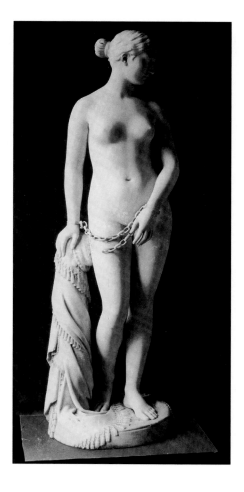

Fig. 12. Hiram Powers, *The Greek Slave*, 1847, marble, 65½ inches high, The Newark Museum, New Jersey, Gift of Franklin Murphy, Jr., 1926, photograph courtesy Art Resource, New York

of the growing number of sculptors who capitalized on this breakthrough.

The story of *Undine* can be traced to medieval legends. According to these tales, undines were Mediterranean sea spirits who were mortal but without souls. To gain a soul and immortality, an undine had to assume human form and trick a mortal into marrying her. She could then leave the sea, but only as long as her mate remained faithful. If he discovered her real identity and rejected her, she was obliged to destroy him.

In the nineteenth century, the story gained prominence through Baron Frederich Heinrich Karl de la Motte-Fouqué's *Undine*, which initially appeared in 1811. With its Northern European setting firmly associated with Romanticism, the novel quickly achieved widespread popularity. Translated into English in 1814, it appeared in America in 1823 as *Undine; or, the Spirit of the Waters, a Melodramatic Romance*. In this tragic story, Undine marries a mortal, Sir Huldebrand of Ringstetten, who eventually betrays her. To avenge her husband's infidelity, she is forced to take his life. The tale's melodramatic content rendered it suitable for adaptation to opera. A production by the little-remembered Albert Lortzing premiered in 1845 and enjoyed critical acclaim in America as early as 1856.[5] Since opera was an accessible form of entertainment in the nineteenth century, the story would have been familiar to a broad, cultured audience.

Artists were also attracted to the theme of Undine, and interpretations were before the public eye in America as early as 1850.[6] Although painters first addressed the subject, sculptors recognized the appeal of the story, as well. Ives was one of five Americans known to base works on *Undine*.[7] The others were Joseph Mozier, Thomas Ridgeway Gould, Benjamin Paul Akers, and Louisa Lander. Only the efforts of Ives and Mozier have come to light, and with the possible exception of Akers's and Lander's unlocated sculptures, dated to about 1855 and 1858 respectively, Ives's was the first to portray the subject.[8]

According to Ives's account book, the sculptor finished the original *Undine* for Roberts in 1859.[9] Roberts and his wife had commissioned Ives to create a full-length statue of their daughter Kitty in 1857, and their satisfaction prompted this subsequent order. After receiving *Kitty* in late 1858, Mrs. Roberts wrote an enthusiastic letter of gratitude and referred to the progress of *Undine*:

I trust that my Undine—tho' so widely different in every aspect from my pet Kitty—will be an *equal* success. I imagine the contrast will be a beautiful as well as a striking one. Do not forget my charges about the drapery, which must of necessity be light and flowing. I wish a happy medium maintained—that my fastidious friends may not have occasion to criticise severely.[10]

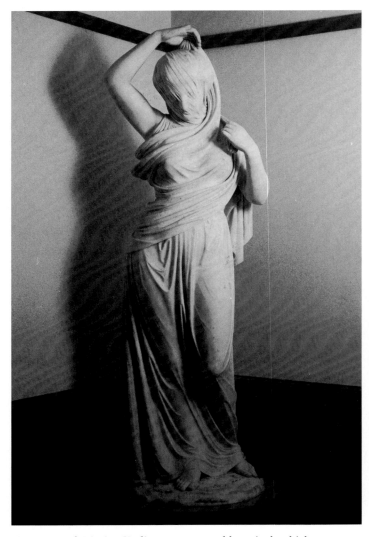

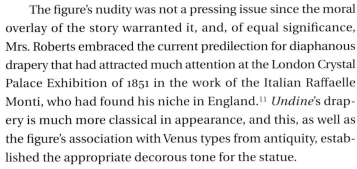

Fig. 13. Joseph Mozier, *Undine*, ca. 1867, marble, 55 inches high, University of Dayton, Ohio

Fig. 14. *Nike of Samothrace*, Musée du Louvre, Paris, France, photograph courtesy Alinari / Art Resource, New York

The figure's nudity was not a pressing issue since the moral overlay of the story warranted it, and, of equal significance, Mrs. Roberts embraced the current predilection for diaphanous drapery that had attracted much attention at the London Crystal Palace Exhibition of 1851 in the work of the Italian Raffaelle Monti, who had found his niche in England.[11] *Undine*'s drapery is much more classical in appearance, and this, as well as the figure's association with Venus types from antiquity, established the appropriate decorous tone for the statue.

Undine arrived in New York in early 1860, and public reaction was favorable, as the press reported the piece was "etherial [*sic*] in contour, delicate in proportions, with lilies and other aquatic flowers at her feet, and that purity of air and expression we associate with a fair spirit of the waters."[12] Initial commercial response was also enthusiastic. By 1865, a fourth replica, ordered by D. N. Crouse of Utica, New York, was on view at the Utica Mechanics' Association.[13]

Undine enjoyed a crescendo of exposure, and in 1872 it was exhibited in New York with Mozier's tour de force (Fig. 13). Each work benefited from the installation, as one critic observed:

Both are strikingly lovely. The Undine of Moshier [*sic*] is veiled, as though by a mist rising from the fountain; the face and form are exquisite, distinctly visible through the misty veil which envelops them. The Undine of Ives represents the water-spirit, after love for Sir Hildebrand had inspired her soul, and she leaves her native element, staning proudly erect, while she casts aside the misty veil which had partially concealed the full radiance of her beauty. An expression of joy and triumph rests upon the half-parted lips, and the upraised arm and hand are of perfect symmetry.[14]

Despite the ongoing praise for this statue, only one more order for this initial version ensued. It was not until about 1880 that Ives commenced his second, far more remunerative, interpretation (Cat. 4).

In his account book, Ives gives a date of 1880 in reference to the second version of *Undine*, but completing the new composition entailed an extended incubation period. In late 1882 a visitor to Ives's studio reported seeing the sculptor at work on

the clay model of *Undine*, which was covered in wet muslin.[15] Ives was striving for the effect of wet drapery and remained mindful of the praise accorded Mozier's statue for its misty, veiled effect.

Unlike *Pandora*, which underwent only minor modifications, Ives completely revamped *Undine* and even interpreted a completely different episode of the story. Rather than the moment early in the story where Undine reveals herself to the noble Huldebrand from her island sanctuary and transforms from sprite to mortal, Ives selected the equally dramatic climax of the tale. He captured the tragic moment when Undine rises like a beautiful fountain from the well to seek revenge on her unfaithful husband. Ives avoided the theme of retribution or the menacing side of his heroine, and *Undine* wears an expression of sad resignation instead of anger. Water spirits were frequently pictured as dangerous creatures who inhabited streams, springs, rivers, lakes, and fountains, waiting to entrap with their songs and physical charms.

The moralizing story of Undine combines the threat of a watery grave with the timeless story of the abandoned woman wreaking revenge on her wayward spouse. Unlike sirens and other water spirits who lure men to their deaths without cause, the vengeful death of Undine's husband was a moral lesson of infidelity punished. Ives, however, did not portray his *Undine* as vengeful but as victimized, tragically caught in the web of her own fate.[16] This emotional restraint was consistent with a certain aspect of classical canon, while the muted sentimentality appealed to the Victorian sensibility.

The beauty of *Undine*'s figure is accentuated by her dress. The wet cloth of her garments cling to her body, reminiscent of the *Nike of Samothrace* (Fig. 14). The delicate carving of the drapery folds and thinness of the marble cloak held high above her head recalls the relief *The Birth of Venus* (Fig. 15). Also known as the *Ludovisi Throne*, this work is one Ives would have encountered during his visits to Roman museums. The emulation of this diaphanous effect imparted a far more sensual result than the nudity of the earlier, more severe version.

Undine seems to float on air as she dances on the wavelets. Her pose and rapturous look connect the work to the Christian tradition of blessed souls rising to heaven on Judgment Day. The more devout members of Ives's audience must have linked the figure's rapture to this Christian experience. Others, with more mundane interests, marveled at *Undine*'s physical charms cloaked in see-through fabric. In any case, the thematic classical or Christian associations countered any prurient response.

Fig. 15. Panel from the Ludovisi Throne depicting the birth of Venus, Museo Nazionale Romano delle Terme, Rome, Italy, photograph courtesy Alinari / Art Resource, New York

Ives made at least ten replicas of *Undine*. Despite its popularity, *Undine* was not exempt from the diminished esteem of Ives's work, which occurred when the market for Neoclassical sculpture vanished in the second half of the nineteenth century. The sculpture's rejection was especially poignant, since Ives endured its failure in person. In 1891 he withdrew the statue from a sale in New York because the only bid did not cover even half the cost of the block of marble.[17] Nevertheless, the exceptional quality of the carving makes *Undine Rising from the Waters* one of the most beautiful pieces of sculpture created in the nineteenth century.

NOTES

1. Much of the information in this entry is drawn from my catalogue, *A Marble Quarry: The James H. Ricau Collection of Sculpture in the Chrysler Museum of Art* (New York: Hudson Hills Press in cooperation with the Chrysler Museum of Art, 1997). I am grateful to Paul Anbinder and William J. Hennessey for their permission to use this material.

2. Douglas K. S. Hyland, *Lorenzo Bartolini and Italian Influences on American Sculptors in Florence (1825–1850)* (New York: Garland Publishing, 1985), pp. 262–63.

3. "American Artists Abroad," *Bulletin of the American Art-Union* (April 1851), pp. 12–13, in a letter from S., dated "Florence, Jan. 20, 1851," reports on Ives's progress. His imminent departure for Rome is recorded in "Fine Arts," *Home Journal* (September 27, 1851), p. 3.

4. Joy S. Kasson, *Marble Queens and Captives: Women in Nineteenth-Century American Sculpture* (New Haven, Conn.: Yale University Press, 1990), p. 166.

5. "Sketchings. Domestic Art Gossip," *Crayon* 3 (November 1856), p. 345. Initially noted in William H. Gerdts, *American Neo-Classic Sculpture: The Marble Resurrection* (New York: Viking, 1973), pp. 82–83.

6. *Scene from Undine*, by Moritz Retzsch, was exhibited at the Albany Gallery of the Fine Arts in 1850; see James L. Yarnall and William H. Gerdts, *The National Museum of American Art's Index to American Art Exhibition Catalogues from the Beginning through the 1876 Centennial Year*, 6 vols. (Boston: G. K. Hall, 1986), 4: 2928.

7. Gerdts, *American Neo-Classic Sculpture*, p. 89.

8. Jan Seidler Ramirez, "Benjamin Paul Akers," in Kathryn Greenthal et al., *American Figurative Sculpture in the Museum of Fine Arts, Boston* (Boston: Museum of Fine Arts Boston, 1986), p. 143, and Charlotte Rubinstein, *American Women Sculptors* (Boston: G. K. Hall, 1990), p. 60.

9. Ives's account book, typescript of original manuscript on file in the Department of American Paintings and Sculpture, The Metropolitan Museum of Art.

10. C. D. [Mrs. Marshall O.] Roberts (New York) to C. B. Ives, November 29, 1858; Chauncey Bradley Ives Letters, 1838–83, Archives of American Art, Smithsonian Institution, Washington, D.C., reel 3134, frames 608–9.

11. John Tallis, *History and Description of the Crystal Palace and Exhibition of the World's Industry in 1851*, 2 vols. (New York and London: John Tallis and Co., 1851), vol. 1, pt. 1, p. 41.

12. Z., "Letter from New York," *Boston Transcript* (February 14, 1860), p. 1.

13. Yarnall and Gerdts, *American Exhibition Catalogues*, 3:1904.

14. "Art Treasures of N.Y.," *Fine Arts* 1 (March 1872), p. 6.

15. "The Notebook," *Art Amateur* 7 (October 1882), p. 91.

16. Kasson, *Marble Queens and Captives*, p. 170.

17. "Art Gossip," *New York Evening Telegram* (March 19, 1891), p. 5.

PROVENANCE

Collection Eugene Leone, New York

LITERATURE

(includes references to all versions of Ives's *Undine Rising from the Waters*)

"The Notebook," *Art Amateur* 7 (October 1882), p. 91; Wayne Craven, *Sculpture in America*, rev. ed. (1968; Newark: University of Delaware Press; New York and London: Cornwall Books, 1984), pp. 286–87, 307, fig. 8.13 (Yale University Art Gallery version); William H. Gerdts, "Chauncey Bradley Ives, American Sculptor," *Antiques* 94 (November 1968), pp. 716, fig. 5 (Yale University Art Gallery version), 717; William H. Gerdts, "Marble and Nudity," *Art in America* 54 (May–June 1971), p. 65 (Yale University Art Gallery version); William H. Gerdts, *American Neo-Classic Sculpture: The Marble Resurrection* (New York: A Studio Book, The Viking Press, 1973), pp. 41, 88–89, fig. 73 (an unidentified version); Joy S. Kasson, *Marble Queens and Captives: Women in Nineteenth-Century American Sculpture* (New Haven, Conn.: Yale University Press, 1990), pp. 169–71, fig. 67, jacket cover (Yale University Art Gallery version); H. Nichols B. Clark, *A Marble Quarry: The James H. Ricau Collection of Sculpture at the Chrysler Museum of Art* (New York: Hudson Hills Press in cooperation with the Chrysler Museum of Art, 1997), pp. 118–20, no. 27, color, frontal view, 121, fig. 55, color, back view, jacket cover, front and back views (Chrysler Museum of Art version).

Related versions of this marble are in the collections of the National Museum of American Art, Smithsonian Institution, Washington, D.C. (life-size, 77⅝ inches high); Yale University Art Gallery, New Haven, Conn. (three-quarters life-size, 60½ inches high); The James H. Ricau Collection at the Chrysler Museum of Art, Norfolk, Virginia (as *Undine Rising from the Waters*, three-quarters life-size, 50⅝ inches high), and private collection, New York (three-quarters life-size, 49¼ inches high).

Two *Undine* marbles were included in the sale at the Madison Square Art Rooms, New York, *Statuary by Mr. C. B. Ives, of Rome, Italy*, November 15, 1883, nos. 13 (as "statue"), 20 (as "statuette"). The sale of Ives's statuary at 432 Fifth Avenue, New York, held on March 17, 1887, also included two *Undine*s. The Spanierman version may have been one of those sold.

Undine Rising from the Waters is recorded in Chauncey Bradley Ives, "Record of Works / Statue of Undine," unpublished manuscript in the collections of the Bartholet family, Connecticut and Massachusetts, transcribed, p. 5 (lists five versions of *Undine* and their original respective buyers).

Thomas Eakins (1844–1916)

5. *An Arcadian*, 1883

Oil on canvas
14 × 18 inches
Inscribed (by Mrs. Eakins) lower right: *Eakins*

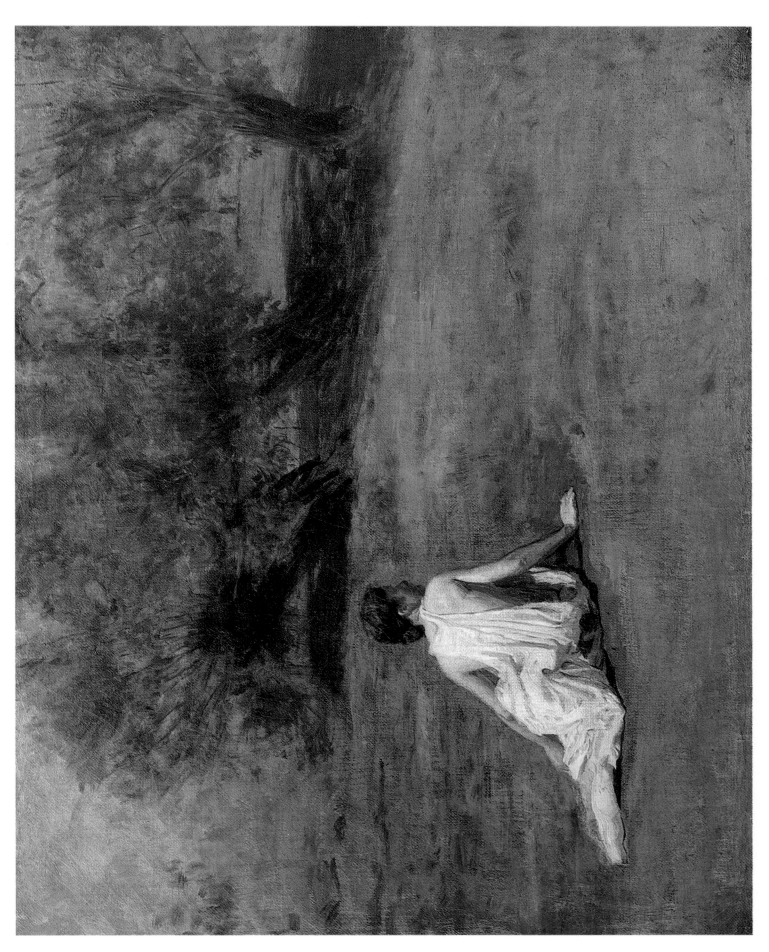

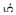

Thomas Eakins: *An Arcadian*, 1883

by Elizabeth Milroy

MUSIC AND THE INTERPLAY between performer and audience are recurring themes in the work of Thomas Eakins.[1] Many of his paintings portray family members or close friends playing musical instruments, singing, or simply listening. Most of these are set in contemporary interiors. But during the early 1880s, Eakins abandoned interior settings to produce a small group of paintings and relief sculptures in which his musicians inhabit the pastoral landscape of classical myth. Called "Arcadians" by Susan Eakins after her husband's death, these works form an intriguing record of Eakins's momentary excursion into the Virgilian tradition.[2]

Recent writers have remarked on the nostalgic, almost elegiac mood of *An Arcadian* (Cat. 5) and the works to which this painting is directly related. Eakins devised these compositions from photographs of friends and family taken amid the rolling meadows and scrub oaks of his brother-in-law's Avondale, Pennsylvania, farm, but he did not translate this setting literally. Instead, Eakins set small groups of figures within a hazy, unfocused envelope of green space, evoking a zone out of time, "a realm irretrievably lost, seen through a veil of reminiscent memory."[3] Indeed, the melancholy mood of these works, on which Eakins seems to have started work in the summer of 1883, has led some writers to suggest that his venture into the

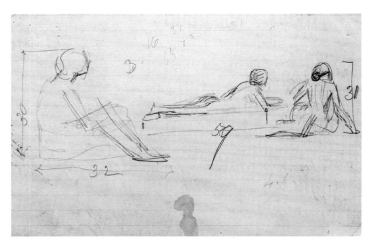

Fig. 17. Thomas Eakins, *An Arcadian: Three Figure Studies*, ca. 1883, graphite on foolscap, 4¹⁵⁄₁₆ × 7¹¹⁄₁₆ inches, Charles Bregler's Thomas Eakins Collection, Pennsylvania Academy of the Fine Arts, Philadelphia, purchased with the partial support of the Pew Memorial Trust and the John S. Phillips Fund

vales of Arcadia may have been prompted by the sudden death of his beloved sister Margaret in 1882.[4]

In her recent study of Charles Bregler's Thomas Eakins Collection, in which were discovered hitherto unknown preparatory photographic studies, an oil sketch and drawing for this series, as well as one of the original plaster reliefs, Kathleen A. Foster notes that Eakins probably worked on the several Arcadian works concurrently. She details how Eakins used photographs to formulate his compositions, in both two and three dimensions. The figure of the reclining woman in the painting *An Arcadian* derives from one of several photographs Eakins made of Susan posed out-of-doors (Fig. 16). Eakins then copied Susan's pose and two others into a working drawing, more than likely, Foster contends, to test compositional variables in the paintings and reliefs then in process (Fig. 17). "From the welter of photo studies, the incompleteness of the paintings, and the strategic implications of this drawing," Foster states, "we can see that the figures in his photographs had become units, readily enlarged and moved around in a compositional game with endless possibilities."[5] Eakins also used the photograph in a small oil sketch in which he added drapery to the figure and plotted the patterning of light and shadow (Fig. 18).

The most fully developed work of the Arcadian series is, not a painting, but a relief sculpture (Fig. 19). Dated 1883, the panel contains a line of men and women, including an elderly philosopher leaning on his cane, and an attentive dog, all of whom stand in reverie before a seated man playing the double flute, or aulos. Their Grecian drapery and seminudity identify

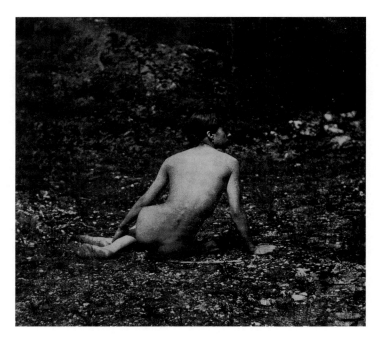

Fig. 16. Circle of Thomas Eakins, *Susan Macdowell Eakins Nude, Sitting, Looking over Right Shoulder*, ca. 1883, cyanotype, 3½ × 4⁷⁄₁₆ inches, Charles Bregler's Thomas Eakins Collection, Pennsylvania Academy of the Fine Arts, Philadelphia, purchased with the partial support of the Pew Memorial Trust

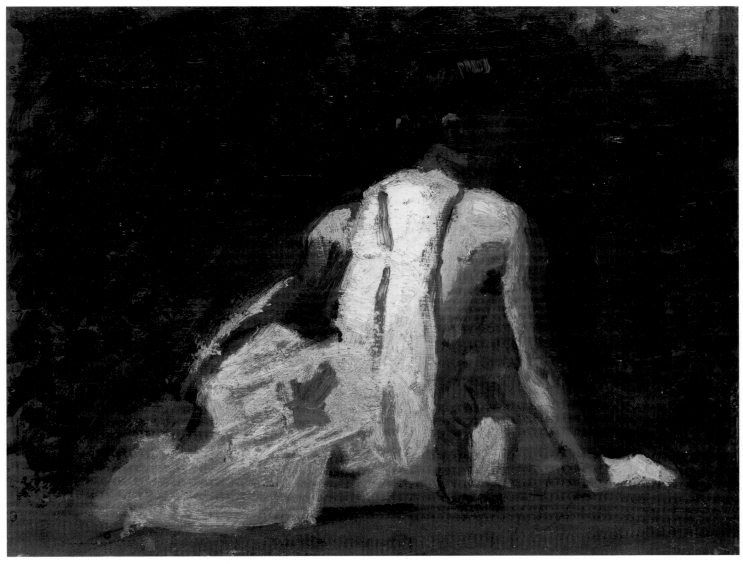

Fig. 18. Thomas Eakins, *An Arcadian*, ca. 1883, oil on wood panel,
8½ × 10⅞ inches, Hirshhorn Museum and Sculpture Garden, Smithsonian
Institution, Washington, D.C., Gift of Joseph H. Hirshhorn, 1966

these figures as classical; the understated poses and measured arrangement of the figures echo antique sources.

The piper appears again in the largest oil version of *Arcadia*, now standing in a verdant meadow before two reclining figures (Fig. 20). One of these, a boy, plays the panpipes while a second figure, a girl, lies, head in hand, listening. Relaxed, unselfconscious in naked reverie, these figures and their music blend harmoniously with nature.

Eakins initially sketched the standing piper into the present smaller *Arcadian* canvas but elected to leave the figure out of the final version, thereby intensifying the focus on the single reclining female against the generalized landscape background. The piper's music is still present; it is heard by this reclining figure, her muscles tense as she leans alertly forward to hear the music of an unseen piper. The network of greens within which she lies resonates as if the sound were made visible. In this canvas, Eakins achieved his most concise yet

telling evocation of the landscape as both psychological and physical environment. (Andrew Wyeth later would play his own variation on the suggestion of yearning melancholy in Eakins's figure in *Christina's World*.[6])

The classicizing idiom of these Arcadian works and Eakins's use of the sculptural relief together form his most direct emulation of the work of the classical sculptor Phidias, author of the Parthenon and one of Eakins's oft-cited role models.[7] Indeed the entire Arcadian series is generally regarded as Eakins's homage to his classical predecessor. "Although sometimes deemed uncharacteristic or 'experimental,'" Foster notes, "these figure paintings express Eakins' primary identity in these years as a teacher and an academic, a link in a human chain stretching back to Greece and, through his students, into the future of a correctly modern art."[8]

These works also complement Eakins's earlier homage to an American sculptor-predecessor, William Rush. In fact, Eakins

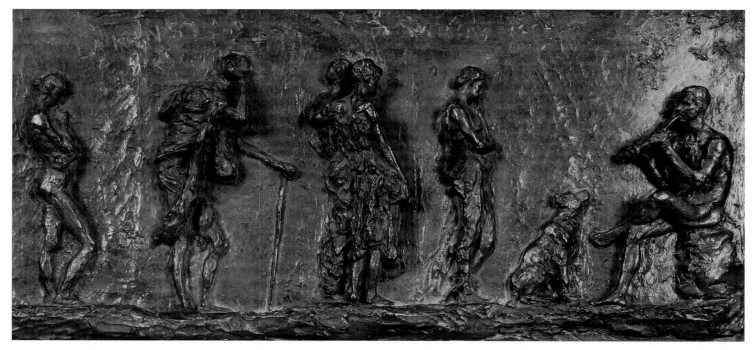

Fig. 19. Thomas Eakins, *Arcadia*, 1883, painted plaster, 11⅞ × 24¼ inches, Hirshhorn Museum and Sculpture Garden, Smithsonian Institution, Washington, D.C., Gift of the Joseph H. Hirshhorn Foundation, 1966

may have begun to sketch out the Arcadian series in his mind as early as the late 1870s, at the time of his first *Rush* paintings. To Eakins and his contemporaries, Phidias was important not only for his work but also as the archetype of the emancipated artist who did not compromise his creative and intellectual instincts. In an 1877 article for *Lippincott's*, published at the same time Eakins was working on his first *Rush* pictures, the artist's longtime friend Earl Shinn observed:

> The fact seems to be that the artistic soul that is strong enough to lead its age always dwells in a state of independence, where art only is law and all creeds are subordinate. Raphael and Phidias both obeyed a classical ideal within them, rather than the religions they respectively served with the furniture demanded.[9]

The self-reliance to which Shinn refers certainly struck a chord with the unconventional Philadelphian. But of particular interest to Eakins was the fact that Phidias had first been a painter and throughout his career sought to marry the effects of color with sculpted form. Was Eakins perhaps experimenting with the reverse problem, removing all extraneous detail in *An Arcadian* to obtain the reductive impact of a relief?

At the time Eakins created his Arcadian works, pastoral landscapes were enjoying particular popularity among European and American artists, including Mariano Fortuny, Frank Millet, and most notably Thomas Wilmer Dewing.[10] At the National Academy of Design annual in 1880, for example, Frank Waller exhibited a painting entitled *Harmony*, which, like Eakins's paintings, features an aulos-playing shepherd

reclining in a landscape.[11] But whereas Eakins's contemporaries created images they intended to be read as existing outside of time, Eakins completed his Arcadian series with a frank affirmation of the present day. For the culminating work in this series, and Eakins's true homage to Phidias, is the lusty and very modern *Swimming Hole* of 1883 (Amon Carter Museum, Fort Worth), a painting, as Goodrich wrote, "straight out of reality."[12]

NOTES

1. For a discussion of musical themes in Eakins's work, see Elizabeth Johns, *Thomas Eakins: The Heroism of Modern Life* (Princeton, N.J.: Princeton University Press, 1983), pp. 115–43.

2. Eakins's Arcadian works have been thoroughly and most perceptively discussed in Marc Simpson, "Thomas Eakins and His Arcadian Works," *Smithsonian Studies in American Art* 1 (Fall 1987), pp. 71–95, and Kathleen A. Foster, *Thomas Eakins Rediscovered: Charles Bregler's Thomas Eakins Collection at the Pennsylvania Academy of the Fine Arts* (New Haven, Conn.: Yale University Press, 1997), pp. 178–88.

3. John G. Lamb, "Eakins and the Arcadian Themes," in *Eakins at Avondale*, exh. cat. (Chadds Ford, Pa.: Brandywine River Museum, 1980), p. 19.

4. The connection with Margaret Eakins's death was first proposed by Julie Schimmel in 1977, who makes reference to Erwin Panofsky's "Et in Arcadia Ego: Poussin and the Elegiac Tradition," in *Meaning in the Visual Arts* (Garden City, N.Y.: Doubleday Anchor Books, 1955), and seconded by Simpson. See also Foster, pp. 178 and 184.

5. Foster, *Thomas Eakins Rediscovered*, p. 183.

6. Donald Miller, "Unusual Women, Famous Paintings," *Pittsburgh Post-Gazette*, July 13, 1987.

7. See especially Lloyd Goodrich, *Thomas Eakins*, 2 vols. (Cambridge, Mass.: Harvard University Press, 1982) 1: 230–37; Darrel Sewell, *Thomas Eakins*:

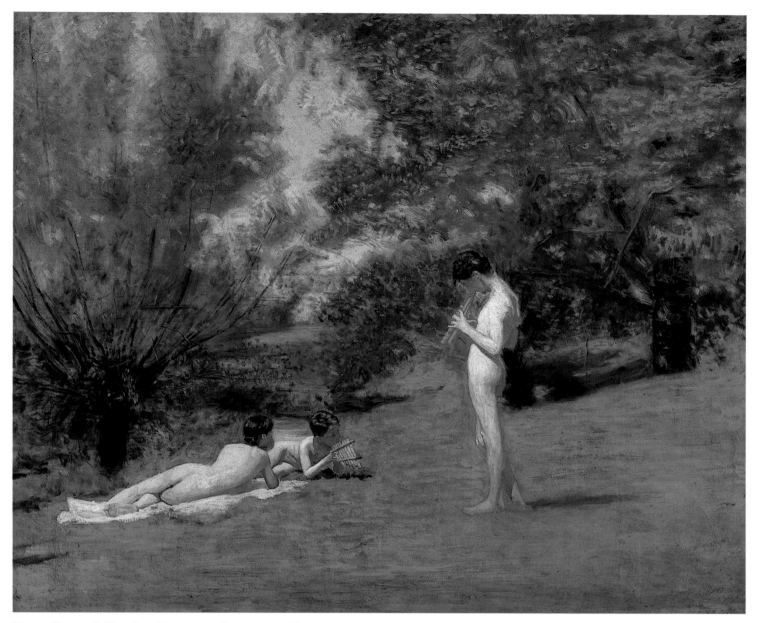

Fig. 20. Thomas Eakins, *Arcadia*, ca. 1883, oil on canvas, 35⅝ × 45 inches, The Metropolitan Museum of Art, New York, Bequest of Miss Adelaide Milton de Groot, 1967

Artist of Philadelphia, exh. cat. (Philadelphia: Philadelphia Museum of Art, 1982), pp. 84–91; and Foster, *Thomas Eakins Rediscovered*.

8. Foster, *Thomas Eakins Rediscovered*, p. 183.

9. E[arl] S[hinn], "Phidias and His Predecessors," *Lippincott's* 19 (January 1877), p. 70.

10. Kathleen Pyne has persuasively argued that Dewing's paintings of young women from the late 1880s and 1890s, often depicted in classical drapery and posed in generalized landscapes similar to Eakins's Arcadians, may have been ideologically informed by the philosophy of social Darwinism espoused by Herbert Spencer. See Kathleen Pyne, "Evolutionary Typology and the American Woman in the Work of Thomas Dewing," *American Art* 7 (Fall 1993), pp. 13–29. Eakins also admired Spencer, and it is interesting to note that the English philosopher made a three-month tour of the United States in 1882—just before Eakins started work on his classical pictures.

11. Waller's painting was illustrated in the *American Art Review* 1 (1879–80), p. 306.

12. Goodrich, *Thomas Eakins*, 1: 237.

PROVENANCE

The artist, 1883–1916; by descent to Susan Eakins, the artist's wife, 1916–ca. 1933; by gift to Mr. and Mrs. Lloyd Goodrich, New York, by 1933.

EXHIBITED

Babcock Galleries, New York, *Thomas Eakins*, December 15, 1930–January 15, 1931, no. 5 (as *Landscape with Seated Figure*); Babcock Galleries, New York, *Sketches, Studies, and Intimate Paintings by Thomas Eakins*, October 31–November 25, 1939, no. 32; M. Knoedler & Company, New York, *A Loan Exhibition of the Works of Thomas Eakins Commemorating the Centennial of His Birth, 1844–1944*, June–July 1944, no. 35 (p. 13, pl. 35); Carnegie Institute, Pittsburgh, *Thomas Eakins Centennial Exhibition*, April 26–June 1, 1945, no. 12, illus.; American Academy and Institute of Arts and Letters, New York, *Thomas Eakins*, 1958, no. 47; National Gallery of Art, Washington, D.C., *Thomas Eakins, A Retrospective Exhibition*, October 8–November 12, 1961, no. 46 (pp. 78 pl. 46, 131) (traveled to The Art Institute of Chicago, December 1, 1961–January 7, 1962, and the Philadelphia Museum of Art, February 1–March 18, 1962); Whitney Museum of American Art, New York,

Thomas Eakins Retrospective, September 22–November 21, 1970, no. 42; Whitney Museum of American Art, New York, *18th- and 19th- Century American Art from Private Collections*, June 27–September 11, 1972; National Collection of Fine Arts, Smithsonian Institution, Washington, D.C., *Academy: The Academic Tradition in American Art*, 1975, no. 105 illus., p. 208; National Academy of Design, New York, *150th Anniversary of the National Academy of Design*, June 6–September 1, 1975; Brandywine River Museum, Chadds Ford, Pennsylvania, *Eakins at Avondale and Thomas Eakins: A Personal Collection*, March 15–May 18, 1980, no. 2 (pp. 11, 18–20, 27, 34 notes 1–2, 36, no. 2), cover illus. in color; Pennsylvania Academy of the Fine Arts, Philadelphia, *Thomas Eakins Rediscovered at Home, at School, and at Work*, September 22, 1991–April 5, 1992.

LITERATURE

Henri Gabriel Marceau, "Catalogue of the Works of Thomas Eakins," *Pennsylvania Museum Bulletin* 25 (March 1930), p. 20, no. 44 (as *Landscape with a Seated Female Figure*); Lloyd Goodrich, "Catalogue of Works," *Thomas Eakins: His Life and Work* (New York: Whitney Museum of American Art, 1933), p. 177 (no. 200); Roland Joseph McKinney, *Thomas Eakins* (New York: Crown Publishers, 1942), p. 106 illus.; Margaret Breuning, "New York Views Art of Eakins in Comprehensive Exhibition," *Art Digest* 18 (June 1, 1944), p. 7 illus. (as *Arcadia*); Fairfield Porter, *Thomas Eakins* (New York: George Braziller, 1959), pl. 34; *Thomas Eakins: His Photographic Works*, exh. cat. (Philadelphia: Pennsylvania Academy of the Fine Arts, 1969), pp. 56 (no. 197), 75 (no. 197); Lloyd Goodrich, *Thomas Eakins* (New York: Praeger Publishers, 1970), p. 70 (no. 42); Gordon Hendricks, *The Life and Work of Thomas Eakins* (New York: Grossman Publishers, 1974), pp. 150–51, 154 (fig. 131); Phyllis D. Rosenzweig, *The Thomas Eakins Collection of the Hirshhorn Museum and Sculpture Garden* (Washington, D.C.: Smithsonian Institution Press, 1977), p. 106; Robert McCracken Peck, "Thomas Eakins and Photography: The Means to an End," *Arts Magazine* 53 (May 1979), pp. 114 (fig. 6), 115–16; Lloyd Goodrich, *Thomas Eakins*, 2 vols. (Cambridge, Mass.: Harvard University Press, 1982), 1: pp. 230, 232 pl. 103 color, 233, 235, 236–37, 251; Darrel Sewell, *Thomas Eakins: Artist of Philadelphia*, exh. cat. (Philadelphia: Philadelphia Museum of Art, 1982), pp. 85–87, 136 note 2; Elizabeth Johns, *Thomas Eakins: The Heroism of Modern Life* (Princeton, N.J.: Princeton University Press, 1983), pp. 128–29 note 22, 130 (Johns lists other works in the Arcadian series); Donald Miller, "Unusual Women, Famous Paintings," *Pittsburgh Post Gazette: Daily Magazine* (July 13, 1987), p. 9 illus.; Marc Simpson, "Thomas Eakins and His Arcadian Works," *Smithsonian Studies in American Art* 1 (Fall 1987), pp. 76 (fig. 6), 77, 80–81, 93 notes 20, 27; Elizabeth Ewing Tebow, *Arcadia Reclaimed in Mythology and American Painting, 1860–1920*, Ph.D diss., University of Maryland, College Park, 1987 (Ann Arbor, Mich.: University Microfilms, 1988), pp. 88, 119 note 10; William Innes Homer, *Thomas Eakins: His Life and Art* (New York: Abbeville Press, 1992), pp. 84 (pl. 72 color detail), 85, 104, 107 (pl. 94 color illus.), 146, 202; Doreen Bolger and Sarah Cash, eds., *Thomas Eakins and the Swimming Picture*, exh. cat. (Fort Worth, Tex.: Amon Carter Museum, 1996), pl. 10 color illus, pp. 99, 110, 113 note 5; Martin A. Berger, "Modernity and Gender in Thomas Eakins's Swimming," *American Art* 11 (Fall 1997), pp. 41 (fig. 8), 43; Kathleen A. Foster, *Thomas Eakins Rediscovered: Charles Bregler's Thomas Eakins Collection at the Pennsylvania Academy of the Fine Arts* (New Haven, Conn.: Yale University Press, 1997), pp. 177–79, 181–82 (fig. 191), 183, 187, 406, 442–43.

Theodore Robinson (1852–1896)

6. *October Sunlight* (*Woman Sewing, Giverny*), 1891

Oil on canvas
18 × 21½ inches
Signed and dated lower left: *Th Robinson 1891*

Theodore Robinson: *October Sunlight* (*Woman Sewing, Giverny*), 1891

by Ira Spanierman

IN JUNE 1891, after returning to Giverny for another summer of painting, Theodore Robinson wrote from the Hôtel Baudy to Thomas Sergeant Perry, husband of the Boston painter Lilla Cabot Perry:

> I am very sorry to hear that Mrs. P. is not well and hope she will improve speedily—you may bring the children and nurse-maid at once—everything will be ready, the same rooms, beds, meals, prices, as before, and I will cast my paternal eye on them from time to time. Giverny is very quiet, there are only a few *pensionnaires* beside myself, tho' great arrangements have been made for the season. . . . The master [Monet] is well, much occupied in his garden where he is planting flowers and things from all parts of the world.[1]

Although it was his custom to spend extended summers in France, returning to New York for the winter months, Robinson had, instead, traveled from Giverny to Italy early in 1891, visiting Capri, Frascati near Rome, and stopping briefly at Antibes in the South of France. By early April he was back in Normandy for yet another summer. His friendship with Claude Monet was well established, he was comfortable in the familiar surroundings of the village, and he anticipated a fruitful period of work.

Throughout his years at Giverny, Robinson was drawn to the theme of a young peasant woman sewing out-of-doors. Such impressive canvases as *The Layette* (Fig. 21), *La Vachère* (1888; The Baltimore Museum of Art), and their related drawings and paintings explore the subject in a range of images that display only minor variations.

For the most part, Robinson used the same model for these compositions, a young woman known only as Marie with whom he had a strong and enduring relationship. She appears in many of his compositions painted in Paris and Giverny from the mid-1880s through 1892, the year of his last visit to France. Both correspondence and entries in his diary reveal that he cared deeply for her, and they would continue to write to one another regularly after Robinson returned to America.

In *October Sunlight*, (*Woman Sewing, Giverny*) (Cat. 6), this composition, more expansive than others employing the theme, the artist has placed the model in a meadow near a thicket of willow trees. Deep shadows suggest that the time of day is late afternoon, and the approaching evening is indicated by the lightly brushed mauve tones above the foliage in the distance. Intent on her sewing, the model pulls the thread through the white fabric that she has casually thrown across her shoulder. She may indeed have brought such handiwork to occupy her as she tends cows in the surrounding meadow.

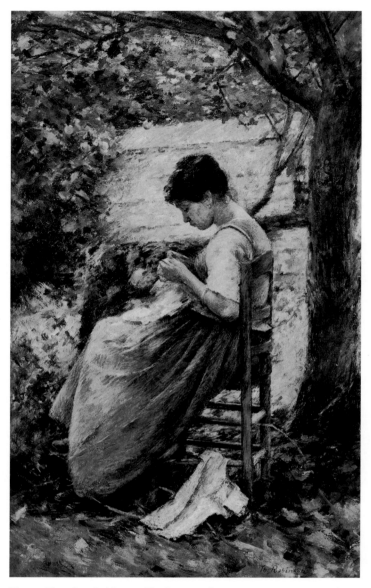

Fig. 21. Theodore Robinson, *The Layette*, oil on canvas, 58⅛ × 36¼ inches, The Corcoran Gallery of Art, Washington, D.C., museum purchase

The early history of the painting has not been determined. However, given the subject and the somewhat abraded date in the lower left corner, it is probably the work entitled *October Sunlight* exhibited at the Society of American Artists, New York, in 1892 and at both the Williams and Everett Gallery in Boston in 1892 and Gill's Art Galleries, Springfield, Massachusetts, in 1894. A diary entry from January 2, 1894, refers to the painting:

> Mr. Gill of Springfield [James D. Gill (1850–1937) was one of the first dealers to specialize in the work of American painters and held annual exhibitions for over half a century.] took my "Oct. Sunlight"—the girl sewing, for his annual ex. He asked me to paint out the date 1891, as it might inter-

Fig. 22. Theodore Robinson, *Woman Sewing, Giverny*, 1891, oil on canvas, 26 × 32 inches, Wichita Art Museum, Kansas, Roland P. Murdock Collection of American Art

fere with its sale! If painters made no worse concessions than that, there would be no great harm, and I cheerfully scratched out the figures.[2]

This painting is one of three versions of the composition presently known. A larger variant exhibits slight differences in the arrangement of certain landscape elements and in the definition of the figure (Fig. 22). It was among a group of some thirty canvases left by the artist at the Hôtel Baudy in 1892 as payment for his board. These works were acquired by the New York art dealer George H. Ainslie about 1922. In a third canvas, vertical in format, Robinson has confined the composition to the image of the model and the willow tree to her left. He has also added a pair of cows in the meadow in the background on the left (The Haggin Museum, Stockton, California). Painted in monochrome, this work was apparently a preliminary study for an illustration accompanying a poem written by the artist for *Scribner's Magazine* (Fig. 23). Interestingly, in the final published version, the composition is again slightly altered with the figure now close to the willow tree and the cows to the right. Entitled *A Normandy Pastoral*, the illustrated verse appeared in June 1897, more than a year after Robinson's death in April 1896 at the age of forty-three.

Certainly, *October Sunlight (Woman Sewing, Giverny)* underscores the role of the figure in Robinson's art, revealing his skill at integrating form and setting and in capturing the varied nuances of sunlight while maintaining a realistic interpretation of his subject. Indeed, *October Sunlight (Woman Sewing, Giverny)* exudes the gentle lyricism that remained one of the hallmarks of Robinson's art. Not surprisingly, his work attracted many admirers, among them the American painter Will Hickok Low, who aptly described him as a "delicate, sensitive artist, receptive to the beauty of atmosphere and limpid play of light over the face of nature."[3]

NOTES

1. Robinson to Thomas Sergeant Perry, June 9, 1891, Archives, American Paintings Department, Museum of Fine Arts, Boston.

2. Theodore Robinson diaries, Frick Art Reference Library, New York.

3. Will Low, *A Chronicle of Friendships* (New York: Charles Scribner's Sons, 1908), p. 477.

Fig. 23. Theodore Robinson, *A Normandy Pastoral, Scribners Magazine* 21 (June 1897), p. 757, published with permission of the Princeton University Library, Princeton, New Jersey

PROVENANCE

Private collection, Missouri; to [art market, Saint Louis, Missouri]; to private collection, Washington, D.C., until 1980; to [Spanierman Gallery, New York, 1980–83]; to [Coe Kerr Gallery, New York, 1983]; to private collection until 1992; to [art market, New York, 1992]; to private collection.

EXHIBITED

(Probably) Williams and Everett Gallery, Boston, *Paintings in Oil and Pastel by Theodore Robinson and Theodore Wendel*, April 1–14, 1892, checklist no. 6 (as *October Sunlight*); (probably) Fifth Avenue Art Galleries, New York, *Fourteenth Exhibition of the Society of American Artists*, May 2–28, 1892, no. 185 (p. 33, as *October Sunlight*); (probably) Gill's Art Galleries, Springfield, Massachusetts, *17th Annual Exhibition of American Paintings*, February 1–March 3, 1894, no. 104; National Museum of American Art, Smithsonian Institution, Washington, D.C., *American Impressions: Masterworks from American Art Forum Collections, 1875–1935, a Daybook*, March 26–July 5, 1993, n.p., color illus. (as *Girl Sewing*).

On the back of a photograph of this painting, John I. H. Baur wrote on August 28, 1980: "In my opinion, this is a genuine painting by the American artist, Theodore Robinson."

This painting will be included in the forthcoming catalogue raisonné of the work of Theodore Robinson by Sona Johnston and Ira Spanierman.

John Henry Twachtman (1853–1902)

7. *River Scene with Pier,* ca. 1893–1894

Oil on canvas

30 × 24 inches

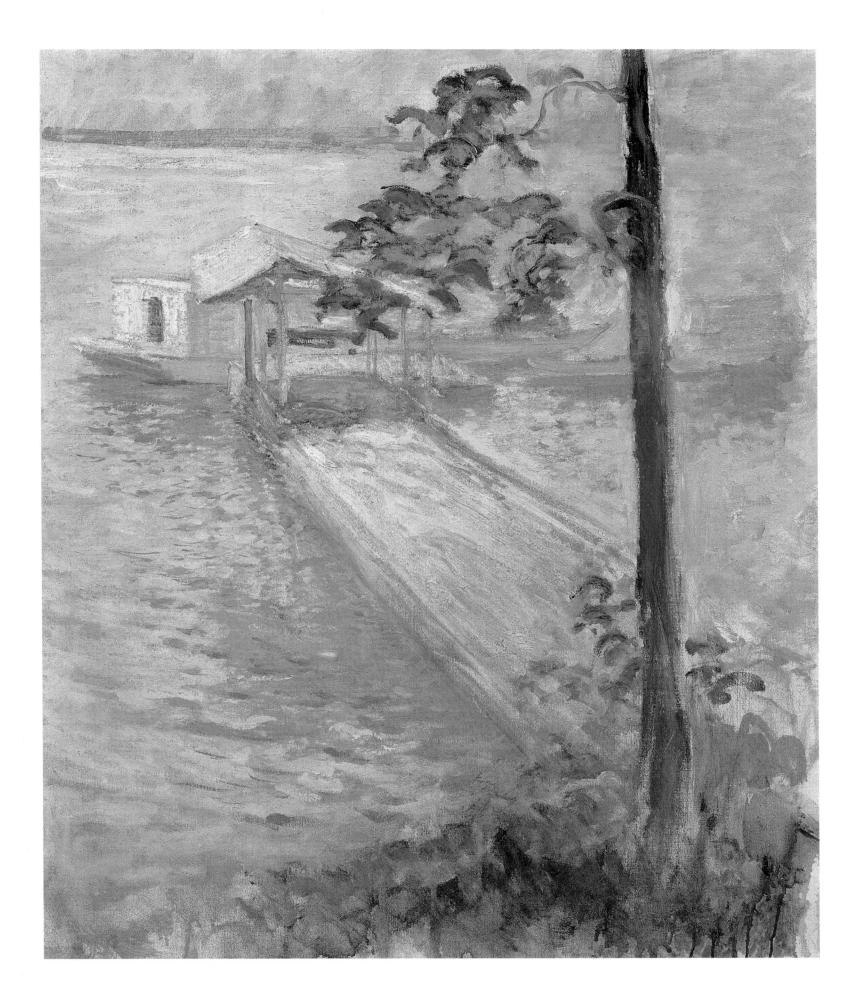

John Henry Twachtman: *River Scene with Pier,* ca. 1893

by Lisa N. Peters

IN THE late nineteenth century, a significant shift occurred in American art. By the early 1870s, the images created by the Hudson River School, which had earlier dominated the nation's exhibitions, had fallen out of favor. As that decade advanced, a new generation of artists emerged who turned away from the literal and didactic approaches popular earlier and sought innovative and subjective modes of expression. They placed a premium on style, adopting the attitude that *how* a work was painted was more important than *what* it depicted. Leaving behind what they perceived to be a provincial tradition, they turned to the art of Europe for inspiration and direction, adopting the techniques and aesthetic attitudes of foreign teachers and mentors. John Twachtman was a leading exponent of this new point of view and a participant in the period's cosmopolitan movement. Committed to portraying the world as he perceived it directly and using novel stylistic means to capture the essence of his subjects through the way he represented them, he epitomized the modern American artist of his era.

Like countless other artists of his time, Twachtman spent a considerable amount of time abroad. In 1875 he left his native Cincinnati for Munich, where he enrolled at the Royal Academy and adopted a dynamic, painterly style inspired by the art of the radical German realist Wilhelm Leibl. In the early 1880s he continued his education in Paris, attending the Académie Julian and absorbing influence from a variety of sources, including the French Barbizon School, the Dutch Hague School, and the art of Jules Bastien-Lepage and James McNeill Whistler. Between 1875 and 1885 he worked in several prominent European painting locales, including Venice, Tuscany, Holland, and Normandy.

Twachtman also participated in the reverse exodus that took place in the late 1880s, when many American artists went home and used their new techniques to depict native subjects.

Settling in Greenwich, Connecticut, in 1889, he found surroundings that satisfied his interests in subtleties in nature, and he painted his home and property in all seasons of the year in a personalized Impressionist style. In the works Twachtman painted during his last three summers in Gloucester, Massachusetts, he combined an Impressionist palette with a more spontaneous method, creating abstracted designs that forecast aspects of twentieth-century modernism.

Content with the familiar scenery of his home and property during his Greenwich years, Twachtman rarely went in search of new subject matter. He did so, however, on two occasions, once to Niagara Falls in 1893 or 1894 and once to Yellowstone Park in Wyoming in 1895. These sojourns resulted in some of his most experimental and original works. Working freely, he showed intimate, uncontrived views of these American icons, bringing out their sensuous qualities rather than their grandeur.

Recent sources have suggested that Twachtman's Niagara works, including *River Scene with Pier* (Cat. 7), were commissioned.[1] It is now clear that they were not, and that the artist chose to travel to this famous site for his own reasons. His stay was, nonetheless, made possible by a prominent Buffalo, New York, figure, Dr. Charles Cary, a physician and teacher, with whom Twachtman stayed during his visit.[2] Indeed, Niagara was an unusual subject for Twachtman. Following its initial portrayal in seventeenth-century guidebooks to the New World, it had become the most recognizable landscape motif associated with America.[3] In depictions by fine artists as well as in commercial reproductions, the falls were shown in romantic terms, their overwhelming force and drama representing the awesome sublimity and divine might that Americans associated with the ebullient spirit of the nation. The image that became the signature representation of the falls was Frederic Church's 1857 *Niagara Falls* (Fig. 24), which was displayed with considerable fanfare at the New York gallery of Messrs. Williams and Stevens. The large-scale, dizzying vantage point and surging waters of Church's painting epitomized the attitude of an era of optimism.

Consistent with the viewpoint of his own generation, Twachtman created views of the falls that were the antithesis of Church's dramatic cataract. Purposefully obfuscating issues of scale, in works such as *Horseshoe Falls, Niagara* (Fig. 25), he focused on the changing rhythms of falling water rather than on the symbolic associations evoked by the subject or on its scenic appeal. While in Niagara, Twachtman sought out another site in addition to the falls. In March 1895 he exhibited an oil at the Society of American Artists entitled *A Pier on Niagara River.* Clearly not an image of the cataract, this painting was described

Fig. 24. Frederic Edwin Church, *Niagara Falls,* 1857, oil on canvas, 42½ × 90½ inches, The Corcoran Gallery of Art, Washington, D.C., museum purchase

Fig. 25. John Twachtman, *Horseshoe Falls, Niagara*, ca. 1893–94, oil on canvas, 30¼ × 25⅜ inches, Parrish Art Museum, Southampton, New York, Littlejohn Collection

by a critic as a "firmly painted" work that "conveys a distinct impression of the place—the embankment with its long line of trees, the crooked pier head, with its pent house and the force of water gliding past it." Another critic discussed it as "a successful study in many ways, but hardly in giving motion to the water, which, we imagine, was his leading intention."[4] The descriptions given suggest that it might have been the painting now entitled *Reflections* (Fig. 26), a work that has not previously been associated with Twachtman's Niagara trip.[5] This painting may well have been the Niagara image that Twachtman's friend and fellow painter Theodore Robinson reported seeing on July 1, 1894: "Called on...Twachtman...and he showd [*sic*] us some canvases done at Niegara [*sic*], very good—one square one—30 × 30 is particularly good. One, on the river, is pretty, but looks to me a little too much like a Monet."[6]

River Scene with Pier helps to link *Reflections* with Niagara. Depicting a similar subject of a pier on a river, this painting has descended in the Buffalo, New York, family of Charles Cary's sister Jenny since the late nineteenth century. Although there are differences in the piers depicted in the two paintings, they could well portray the same site. Indeed, Twachtman often took liberties with his sites, modifying them to suit a particular conception or composition.

River Scene with Pier reveals Twachtman's keen sense of design. His use of a high viewpoint looking down toward the water typifies his ability to select perspectives that are startling

and elegant. In this case, the steep drop to the water creates a dramatic sense of foreshortening that emphasizes the picture's depth and pulls our gaze rapidly into the distance. A simple stroke of paint that indicates the presence of the horizon creates a rhythmic counterforce to the quick movement across the expanse of open water. Such subtle countertensions characterize Twachtman's finest works.

Twachtman's arrangement reflects his familiarity with oriental art. Along with his fellow painters Robinson and J. Alden Weir, he was an avid admirer of Japanese prints. During the 1890s the three artists viewed Japanese prints together at the Boussod-Valadon Gallery in New York and studied with former Tile Club member Heromichi Shugio, who "explained certain things about prints and books" during a dinner at Weir's that was attended by Twachtman and Robinson.[7] Certainly, the impact of the aesthetics of *japonisme* is evident in the simplified composition of Twachtman's *River Scene with Pier*, with its high horizon and bird's-eye viewpoint, and most importantly in the cropped tree and branches in the foreground, which imbue the scene with the decorative, two-dimensional quality found in Japanese prints such as Hiroshige's *Yabu Lane at the Foot of Mount Atago* from *One Hundred Views of Edo* (Fig. 27). Like Hiroshige, Twachtman placed a dark tree trunk on a parallel with the picture plane, offsetting the diagonal extending into the space, and adding to the abstract beauty of the composition.

In Twachtman's image, the tree silhouetted against the water is especially noteworthy since it creates a sense of mystery—the solidity of the earth versus the lighter, more ephemeral qualities

Fig. 26. John Twachtman, *Reflections*, ca. 1890–1900, oil on canvas, 30 × 30¼ inches, Brooklyn Museum of Art, Dick S. Ramsay Fund

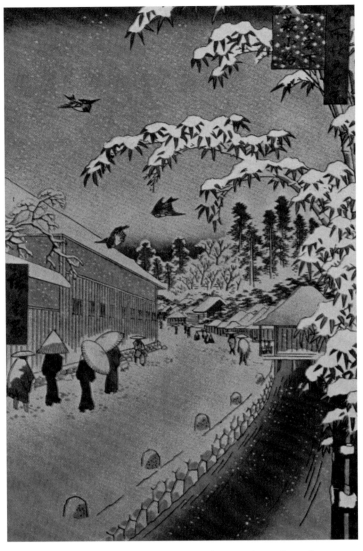

Fig. 27. Hiroshige, *Yabu Lane at the Foot of Mount Atago*, from *One Hundred Views of Edo*, 1857, published by Uoya Eikichi

NOTES

1. See Richard J. Boyle, *John Twachtman* (New York: Watson-Guptill, 1979), p. 19, and Lisa N. Peters, *John Twachtman: Connecticut Landscapes*, exh. cat. (Washington, D.C.: National Gallery of Art, 1989), pp. 31–32.

2. The date of Twachtman's trip to Niagara is somewhat unclear. Obviously he had visited the falls by the winter of 1893–94 since he showed a winter scene of Niagara entitled *Horseshoe Falls, Niagara—Afternoon* at the National Academy of Design exhibition that opened on April 2, 1894. This painting could have been *Niagara in Winter* (New Britain Museum of American Art, New Britain, Conn.) or *Horseshoe Falls, Niagara* (Parrish Art Museum, Southampton, N.Y.). However, Twachtman also appears to have painted Niagara in the summer of 1894, since fellow artist Theodore Robinson wrote in his diary March 9, 1895: "P.m. to Twachtman's—saw one of his Niagara's done last summer—a charming thing and very complete—light, mysterious." Robinson diaries, Frick Art Reference Library, New York (hereafter FARL). Robinson could have been misinformed as to when Twachtman's Niagara trip occurred, but Twachtman did create Niagara paintings that appear to be summer views, including *Niagara Falls* (National Museum of American Art, Washington, D.C.) and *Niagara Falls* (collection of Mr. and Mrs. Raymond J. Horowitz). Thus, it is conceivable that Twachtman visited Niagara twice, or that he created some of his images from secondary sources.

3. A comprehensive discussion of artists' views of Niagara and how the subject has been perceived historically is Jeremy Elwell Adamson et al., *Niagara: Two Centuries of Changing Attitudes, 1697–1901*, exh. cat. (Washington, D.C.: The Corcoran Gallery of Art, 1985).

4. "The Society of American Artists," *Art Amateur* 32 (May 1895), p. 158, and "The Fine Arts: Exhibition of the Society of American Artists," *Critic* 23 (March 30, 1895), p. 150.

5. The idea that *Reflections* might be an image of Gloucester was suggested in Lisa N. Peters, entry in *Twachtman in Gloucester: His Last Years, 1900–1902*, exh. cat. (New York: Spanierman Gallery, 1987), p. 54.

6. Robinson diaries, July 1, 1894 (FARL).

7. Robinson diaries, April 8, 1894 (FARL). On Weir's involvement in *japonisme*, see Doreen Bolger Burke, *J. Alden Weir: An American Impressionist* (Newark: University of Delaware Press, 1983), pp. 202–12. See also Doreen Bolger, "American Artists and the Japanese Print: J. Alden Weir, Theodore Robinson, and John H. Twachtman," in *American Art around 1900: Lectures in Memory of Daniel Fraad* (Washington, D.C.: National Gallery of Art, 1990), pp. 15–27.

PROVENANCE

Lawrence Rumsey and Jenny Cary Rumsey, early 1900s; by descent to their daughter Evelyn Rumsey Lord; to private collection, 1998.

Jenny Cary was the sister of Charles Cary, with whom Twachtman stayed in Buffalo while painting views of Niagara Falls in 1893. The subject of the work is most likely the Niagara River, below Niagara Falls.

This painting will be included in the forthcoming catalogue raisonné of the work of John Henry Twachtman by Ira Spanierman and Dr. Lisa N. Peters.

of the water. So, too, do Twachtman's fluid brushwork and palette, a blend of luminous and ethereal blues, mauves, pinks, and greens, which capture the effect of diffused sunlight mingling with the vaporous mist that has settled over the river. Indeed, in *River Scene with Pier*, Twachtman's skillful manipulation of color, his agile, versatile technique, and his minimalist arrangement evoke the transitory effects of light and air, creating a mood of tranquility.

Many late-nineteenth-century American artists adopted the new emphasis on style over subject, but Twachtman was one of the few to marry style and subject perfectly. Capturing the reality of nature while distilling the subject to its evocative essence, in *River Scene with Pier*, Twachtman underscored his reputation as one of the most poetic, and modern, American artists of his era.

William Merritt Chase (1849–1916)

8. *Sunset at Shinnecock Hills,* ca. 1900

 Oil on canvas
 33 × 40 inches
 Signed lower right: *Wm M. Chase*

8.

William Merritt Chase: *Sunset at Shinnecock Hills,* ca. 1900

by Ronald G. Pisano

AFTER SIX YEARS of study at the Royal Academy in Munich, William Merritt Chase returned to the United States in 1878 and soon established himself as one of America's most eminent artists and art teachers. He chose to live in New York City, which was by then the art center of the country, but nearly every summer he returned to Europe to visit the great art galleries of the Continent and to renew his relationships with artist friends. His work, eclectic in nature, was greatly dependent on this regular pilgrimage, not just for stylistic reasons but for spiritual ones as well, because his contact with great works by both old masters and modern painters revitalized his own art.

By the mid-1880s, however, Chase's situation began to change. Landscape painting, previously a minor aspect of his oeuvre, became a prominent element in his career. Unquestionably Chase had discovered his métier—painting the figure in a landscape setting. He had practiced plein-air painting for the first time on a trip to Long Island with the Tile Club in 1881. He furthered his study of outdoor light in Holland in the early 1880s, and during the second half of the decade he applied what he had learned to his native landscape. After his marriage in 1886 to Alice Gerson, he had additional reasons to remain rooted in America, and his domestic responsibilities kept him closer to home during the summer months. He spent his time with his family in Brooklyn, devoting his artistic attention to leisurely activities he witnessed in nearby parks and at the shore. His wife and their young children served as models for many of these genteel scenes, which were praised by critics for both their style and technique and their subject matter. Unlike many successful American artists who chose to paint quaint villages in foreign lands or the breathtaking splendor of the western frontier, Chase portrayed what he knew best, America's growing leisure class engaged in pursuits of sanctioned pleasure: reading novels, strolling in parks, or picking flowers.

In 1890 the setting for these scenes shifted from the parks of Brooklyn to Manhattan, most particularly Central Park. In that year, Chase was also given the opportunity to expand his painting territory beyond the confines of New York City when Beatrice Hoyt, a wealthy society woman and amateur painter, invited him to visit her summer home in Southampton. There she proposed that he direct a summer school of art in the nearby dunes of Shinnecock Hills, which are bounded on one side by Shinnecock Bay and on the other by Peconic Bay. Although most saw no merit in these nearly barren sand hills, Chase immediately recognized their artistic potential and the following year established what one critic referred to as "A School in the Sands," and which Chase formally named the Shinnecock Summer School of Art. In 1892 his summer home,

Fig. 28. William Merritt Chase house from the front, ca. 1908, cyanotype, 2½ × 4¼ inches, The Parrish Art Museum, Southampton, New York, The William Merritt Chase Archives

designed by his friend the prominent architect Stanford White, was completed about two or three miles west of the Art Village, a small compound that included the school's teaching studio and cottages for approximately one hundred students who regularly attended summer classes (Fig. 28). Chase's early biographer, Katharine Metcalf Roof, described the setting of Chase's home as being "surrounded by bay, sweet-fern, and vivid patches of butterfly weed...its nearest neighbor off on a distant hilltop."[1] An early visitor to Chase's summer residence recalled:

> Last summer I had opportunities for watching, during his vacation, one of the most distinguished artists that we have. His days were so full that I sometimes wondered that he did not look fatigued. And yet this was his vacation. Down on the southern shore of Long Island, where heather-covered hills of sand stretch from the encroaching bays to the open sea, he had pitched his tent, and was busy with his delightful work. His tent was not of a primitive sort, like that a nomad uses, but a charming and substantial house, designed by a brother artist, Mr. Stanford White.[2]

Lasting until 1902, the Shinnecock Summer School of Art was the first major school of plein-air painting in America. On the occasion of an exhibition of his Shinnecock students' works in 1897, Chase proclaimed:

> Many people say we have no school of art in America; but I do not agree with them. The studies of our Shinnecock School which cover these walls tonight are representative of American art. There is no staining, no tinting, but here is American painting which will produce good results. Let me urge you to strive to prove that our American art is a vital thing.[3]

It is clear that Chase was striving for the same goal in his own work. The directness and vitality of his paintings of this period have been acclaimed by critics past and present. Like his park scenes from the previous decade, his most popular compositions of the 1890s are those that focus on his own domestic life and convey the relaxed holiday spirit of family summer vacations. These charming images are unencumbered by any narrative messages so often associated with genre paintings of the period. Aside from being imbued with the bright light and clear skies that typify eastern Long Island, they are personal, joyful, and yet unsentimental renditions of the artist's summer holidays. With Chase's characteristically bold, swift brushwork, his bright, impressionistic palette, and his uncanny ability to capture a fleeting moment in time, these Shinnecock landscapes masterfully portray the carefree moments of leisure-class America at the turn of the century—a period since referred to as the "picnic generation."

The site of these works is the area near his Shinnecock home, which often appears as either a major element or a distant accent. Other paintings have as their setting (and some-

Fig. 29. Dorothy, Helen, and Robert outside Chase house, Shinnecock Hills, New York, ca. 1901, gelatin printing out-paper, 6½ × 4¾ inches, The Parrish Art Museum, Southampton, New York, The William Merritt Chase Archives

times their subject) the old sand road that led to this house. Still others are set in the surrounding dunes. And within this body of work, those rare Shinnecock landscapes that include figures are his best. In these images, Chase explored the relationship of the figure to the landscape in highly inventive, unformulaic compositions in which he subtly related the two, achieving coloristic and compositional harmony. As Roof observed in 1910:

> The exact value of a crisp little pink hat, a red bow, a child's colored stockings, a woman's parasol in relation to the wide sweep of the Shinnecock moors, the small figures in that quiet plane of grass of many colors yet one value—these qualities belong to Chase. They are not imitable and are recognizeable the minute the eye falls upon the canvas in a gallery.[4]

Chase's use of figures for delightful personal vignettes as well as clever compositional devices is evident in renowned Shinnecock paintings including *The Fairy Tale* (1892; Collection of Mr. and Mrs. Raymond J. Horowitz) and *The Bayberry Bush* (ca. 1895; Parrish Art Museum, Southampton, N.Y.), in which his wife and children enjoy freedom and closeness, while their forms are discreetly linked with their settings, serving as counterpoints and accents to landscape elements.

As in these works, in *Sunset at Shinnecock Hills* (Cat. 8) Chase rhythmically integrated the figure into the arrangement.

Eclipsed by expansive dunes, Chase's fourth child, nine-year-old daughter Dorothy (b. 1891), looks west toward the setting sun, which casts a long shadow behind her. (A photograph from the Chase Archives at the Parrish Art Museum in Southampton shows Dorothy with two of her younger siblings standing beneath the roof awning of the house, much as she stands in the painting [Fig. 29].) The lower third of the figure is in a shadow cast by the welcoming shade of the family home toward which she looks. Shielding her eyes, she looks upward, her gaze perhaps meeting that of her father. Thus Chase, possibly standing at his easel, implies his own presence in the picture.

The composition of this work, in which a large shadow falls from an object outside of the composition, was employed by Chase on at least one other occasion in his painting *The Big Tree Shadow* (private collection). In this work the shadow of a large tree is used to provide the broad foreground space and to act as a foil to the bright advancing colors of the remaining two-thirds of the composition. Unlike *The Big Tree Shadow*, however, which is devoid of any human presence and is actually an image of desolation, *Sunset at Shinnecock Hills* has just the opposite effect. Depicting the young girl who shields her eyes from the bright rays of the setting sun and looks homeward as well as toward the viewer, the painting elicits feelings of personal ties and draws us immediately into the composition as active participants.

From a purely compositional point of view, the figure, partially in bright sunlight and partially in shadow, unites the two elements of sun and shade—the light being nature's spotlight and the shadow on the foreground serving as a stage. On stage, of course, is Dorothy—returning from a late afternoon walk in the dunes with a handful of orange flowers, possibly the butterfly weed mentioned by Roof. The large sumac bushes behind her and to the right offset the large shadow of the house, and the cloud formations on the horizon rhythmically echo those of the bushes. The bright late afternoon light also leads the viewer through the picture, beginning with Dorothy's highlighted russet bouquet. The eye is then directed around the large bush to the right and back to the figure. Finally, attention is directed back to the viewer by Dorothy's direct gaze. Chase beautifully balances this asymmetrical composition by cleverly playing off the strong light reflected on Dorothy's white dress against the shadow cast by the house and the large bush, while using the orange hues of the autumn-tinted grasses and leaves as unifying elements.

However, this is not the extent of Chase's intentions. On another, less obvious level he has created a study of sunlight and shadow—the true essence of most of his plein-air landscapes painted at Shinnecock Hills. The importance of capturing special effects of light is inherent in the titles he chose for many paintings that he sent to exhibitions during the 1890s, including *Sunlight and Shadow*; *Sunset Glow, Shinnecock*; *The Last Glow, Shinnecock*; and *The Sun's Last Kiss.* Chase professed that he was not an Impressionist, but he did adhere to some of the Impressionists' principles, such as painting directly from nature and attempting to capture specific chromatic effects. Gradually, he also began to accept the French Impressionist practice of using color to depict shadow and reflected light. This approach is exemplified by *Sunset at Shinnecock Hills*. With the shadows cast by the young girl and the bush represented in tones of blue-gray and the blaze of summer light that ignites the dunes with a blend of gold and orange intermixed with accents of pale blue, russet, and peach, the painting represents the high point of his foray into Impressionism.

In addition to being a technical tour de force, *Sunset at Shinnecock Hills* has great personal appeal. Without being saccharine, it evokes a definite mood; it is the end of the summer season (probably late September) when Chase's teaching responsibilities were completed, and he had the freedom to paint on his own and to spend more time with his family. His delight in a simple and charming moment when his daughter seeks the comfort of home after wandering in the open dunes is expressed by the artist in a seemingly effortless fashion as if the paint had been breathed on the canvas.

NOTES

1. Katharine Metcalf Roof, *The Life and Art of William Merritt Chase* (1917; reprint, New York: Hacker Art Books, 1975), p. 176.

2. John Gilmer Speed, "An Artist's Summer Vacation," *Harper's New Monthly Magazine* 3 (June 1893), p. 4.

3. William Merritt Chase, "Talk on Art," *Art Interchange* 127 (December 1897), p. 127.

4. Katharine Metcalf Roof, "William Merritt Chase: An American Master," *Craftsman* 18 (April 1910), p. 41.

PROVENANCE

The artist; Mary Elizabeth Lyman, Middlefield, Connecticut, about 1900; by descent through the family; [Spanierman Gallery, New York]; private collection, 1987.

EXHIBITED

Spanierman Gallery, New York, *William Merritt Chase: Master of American Impressionism*, November 2, 1994–January 31, 1995, no. 32 (pp. [3], [4] color illus.).

LITERATURE

Ronald G. Pisano, *Summer Afternoons: Landscape Paintings of William Merritt Chase* (Boston: Little Brown and Company, 1993), pp. 4, 10, 21 color illus.; Raymond J. Steiner, "William Merritt Chase at the Spanierman Gallery," *Art Times* (December 1994), p. 8 illus.; Holland Cotter, "Art in Review: William Merritt Chase 'Master of American Impressionism,'" *New York Times*, January 6, 1995, p. C24 illus.

This painting will be included in Ronald G. Pisano's forthcoming catalogue raisonné of the work of William Merritt Chase.

Childe Hassam (1859–1935)

9. *Cathedral Spires, Spring Morning*, 1900

Oil on canvas
36 × 25¾ inches
Signed and dated lower right: *Childe Hassam 1900*

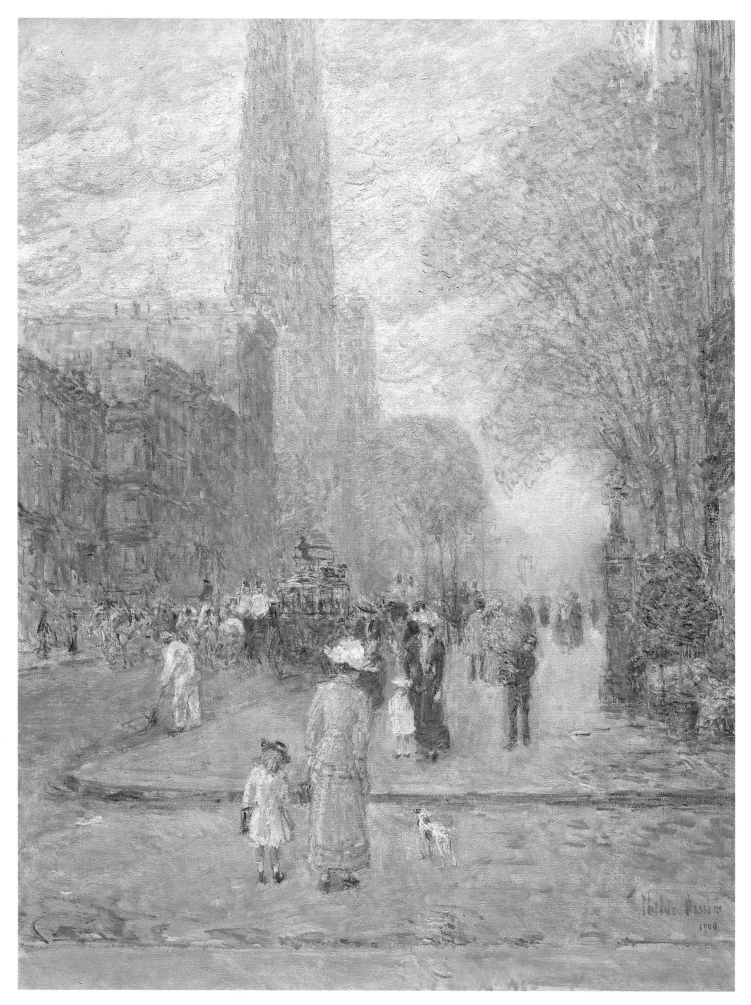

9.

Childe Hassam: *Cathedral Spires, Spring Morning*, 1900

by William H. Gerdts

B Y THE EARLY years of the twentieth century, Childe Hassam was recognized as the leading exponent of the American Impressionist movement.[1] Hassam, born in Dorchester, Massachusetts, had grown up and begun his artistic career in Boston, but after several trips to Europe, he settled in New York in 1889. That city remained his home base for the remainder of his career, though Hassam traveled frequently— back to Europe, throughout New England, to Oregon and California, and to Cuba. In 1898 Hassam visited East Hampton, Long Island, where over two decades later he acquired a permanent summer home. Hassam devoted his art to all these localities. He was also undoubtedly both the most prolific of the American Impressionists and one of the most adventurous in his investigation of various media, in his choices of stylistic strategies from Tonalist to Impressionist to Post-Impressionist, and in his subject matter, which encompassed pure landscape and pure figure work, a great many figure-filled landscapes, still lifes, garden scenes, genre, and allegorical paintings.

Probably the theme for which Hassam gained greatest prominence, however, and certainly the one for which he first acquired critical renown was the depiction of the modern urban landscape. Indeed, Hassam may be thought of as the pioneer of this subject, which he began to undertake in the mid-1880s when still in Boston. There he created pictures such as his justly famous *Rainy Day, Columbus Avenue, Boston* (Fig. 30), scenes painted in a dramatic, tonal manner, often with rain-dampened pavements or in snow.[2] Soon after Hassam made his second trip abroad in 1886, settling in Paris in October, he turned his attention to depictions of the French capital, most notably in his recording of Grand Prix Day (Fig. 31), but now infusing the scene with the color and light of Impressionism. And in the autumn of 1889, after three years abroad, Hassam returned to the United States, settling, not back in Boston, but in New York.

Hassam's first studio apartment was at 95 Fifth Avenue, at Seventeenth Street. Although he moved after three years, first to the Chelsea Hotel on West Twenty-third Street, and then, after a year, to the Rembrandt Studio Building at 152 West Fifty-seventh Street, the vicinity of his first studio—the area from Washington Square to Union Square and then to Madison Square—occupied much of his attention during the autumn, winter, and spring seasons; during the summers he was generally in New England. It was the body of urban imagery that he

Fig. 30. Childe Hassam, *Rainy Day, Columbus Avenue, Boston*, 1885, oil on canvas, 26⅛ × 48 inches, The Toledo Museum of Art, Ohio, purchased with funds from the Florence Scott Libbey Bequest in Memory of her Father, Maurice A. Scott

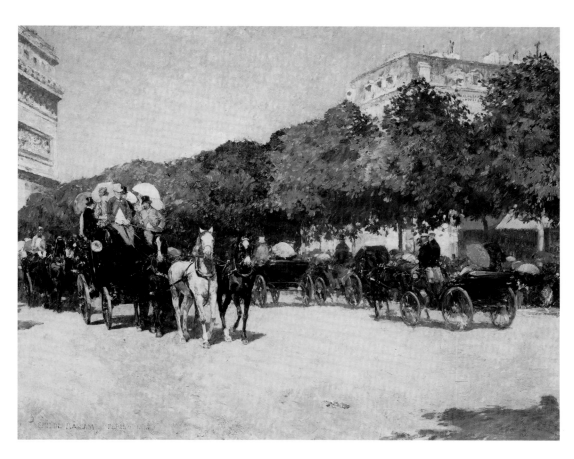

Fig. 31. Childe Hassam, *Grand Prix Day*, 1887, oil on canvas, 24 × 31 inches, Museum of Fine Arts, Boston, Massachusetts, Ernest Wadsworth Longfellow Fund

produced during the 1890s, painted during varied weather conditions and at different times of day and night, that first gained Hassam national prominence.

Many of these paintings are panoramic views of the city and its squares painted from on high. Other, smaller works concentrate on individual figures or groups of figures—generally either fashionably garbed women or groups of cabmen and their hacks. But there is also a body of street scenes that might be designated as "promenade pictures"—that is, street-level views of groups of pedestrians, along with cabs, nursemaids, and other workers making their way almost invariably along Fifth Avenue, the city's most elegant street. Hassam himself declared: "There is nothing so interesting to me as people. I am never tired of observing them in everyday life, as they hurry through the streets on business or saunter down the promenade on pleasure."[3] During the 1890s Hassam was considered the "street painter par excellence,"[4] and he created such works in both oils and watercolors beginning in 1890. Some of them, such as his 1891 *Fifth Avenue at Washington Square* (Fig. 32), truly define the specific nature of the stretch of the avenue that he chose to paint. Lower Fifth Avenue had once been home to many of the first families of New York and, after falling on comparatively hard times, the first five blocks of the avenue, up to Thirteenth Street, were enjoying a renaissance at the end of the century with buildings being restored, remaining, as Mariana Van Rensselaer stated in 1893, a "good residence neighborhood."[5]

But even at the beginning of his New York career, Hassam had ventured up to the Fifties, then the toniest area of Fifth Avenue, at and above St. Patrick's Cathedral. Designed by James Renwick in the Gothic-Revival style, the cathedral was erected in 1879, but its spires were not added until 1888. The fashionable St. Thomas's Episcopal Church, built in 1870 and the masterpiece of the architect, Richard Upjohn, stood at the northwest corner of Fifty-third Street, while the Fifth Avenue Presbyterian Church rose up on the northwest corner of Fifty-fifth Street, considered the "richest of its communion in America—some say, in the world."[6] The University Club, on Fifty-fourth Street between the two churches, was only built in 1900, replacing St. Luke's Hospital, which was demolished in 1895. There were private buildings, as well. The Vanderbilt family had bought up successive blocks in the area. William H. Vanderbilt (son of the great railroad magnate, Commodore Cornelius Vanderbilt) built two imposing homes, one for himself and one for his married daughters, between Fifty-first and Fifty-second streets; his son William K. Vanderbilt built on the northeast corner of Fifty-second Street; and another son, Cornelius II, purchased the northwest corner of Fifty-seventh Street (in 1894 he enlarged this to extend all the way to Fifty-eighth Street). Across Fifty-seventh Street, on the southwest corner, lived Harry Payne Whitney, Cornelius II's son-in-law, while across the street from Whitney's was Collis Huntington's home. John D. Rockefeller's house was just in at 4 West Fifty-fourth Street, while others in the neighborhood included those of Jay Gould, Henry Flagler,

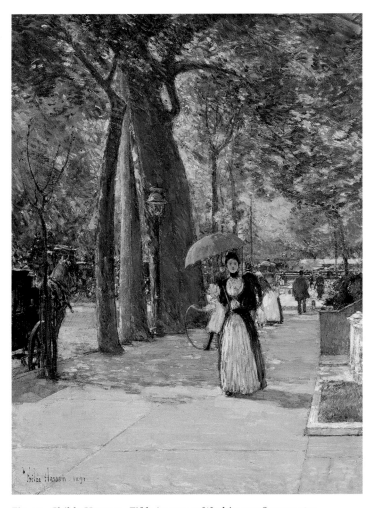

Fig. 32. Childe Hassam, *Fifth Avenue at Washington Square*, 1891, oil on canvas, 22 × 16 inches, Thyssen-Bornemisza Collection, Lugano, Switzerland

Benjamin Altman, Solomon Guggenheim and many others of the richest families in the city.[7]

It was here that Hassam painted one of his first promenade pictures, the large watercolor, *A Sunday Morning on Fifth Avenue* (private collection), with elegantly dressed women and children and top-hatted men sauntering up and down the avenue. Such works were surely meant to appeal to a clientele who might actually have been resident in the area, or at least to reflect the climate of sophisticated living associated with this stretch of the avenue. But one should probably also recognize that Hassam's promenade pictures, generally based either on lower Fifth Avenue or in the Fifties, differ in a subtle way. There are fewer figures in the pictures painted just above Washington Square, and they move slightly more leisurely, reflecting the revivification of old, traditional Knickerbocker New York. Those who appear above St. Patrick's Cathedral are more animated, and there are more of them in the paintings.

This is true of *A Sunday Morning on Fifth Avenue* and also of *Cathedral Spires, Spring Morning* (Cat. 9), painted in 1900. Here the viewer probably looks across to the southwest corner of Fifty-third Street, following a mother and daughter with their dog crossing the street, while a like pair of figures comes toward us, and near them a messenger boy carrying a large plant; other men and women are farther back on the sidewalk. On Fifth Avenue, a public horse-drawn conveyance is going downtown, while a private horse-drawn carriage is coming in the opposite direction. At the far left is the four-story Langham Family Hotel, at the northeast corner of Fifty-second Street, and towering over the whole scene are the twin spires of St. Patrick's Cathedral, a block below. The buildings immediately at the west corner of Fifty-third and Fifth consisted of a row of brownstones, and the trees and potted shrubs fronting them may have been Hassam's invention. The issue of location is complicated, since the only growth of trees on the east side of the avenue in the Fifties would seem to have been just south of the First Presbyterian Church—that is, the southwest corner of Fifty-fifth Street, where St. Luke's Hospital had been, but the distance down the avenue to St. Patrick's would seem to be too great. And the matter is further tangled by the existence of a near-replica of *Cathedral Spires, Spring Morning*, the smaller *Fifth Avenue from Fifty-sixth Street* (Fig. 33), also painted in 1900 and described in a 1916 auction catalogue as "A view of Fifth Avenue in early summer looking south from the westerly corner of Fifty-sixth Street, where formerly there was a florist's shop. Further down on the west side are the trees in the old St. Luke's Hospital Garden."[8] But Fifty-sixth Street would be even more distant from St. Patrick's Cathedral.

Numerous differences exist between *Cathedral Spires, Spring Morning* and *Fifth Avenue from Fifty-sixth Street*. In the latter, the woman crossing the street is in yellow rather than green and is childless, as is her counterpart moving north, while the placement of other figures is also slightly changed. *Cathedral Spires, Spring Morning* may more specifically be identified as representing the city in the month of June, for the picture may be Hassam's *Cathedral and Fifth Avenue in June*, which appeared in a one-artist show at Boston's St. Botolph Club from October 19 to November 17, 1900; unfortunately, no reviews of that show have yet been found that describe this work, but the subject and date would seem to correspond.[9] Unlike the earlier watercolor, *Sunday Morning on Fifth Avenue*, *Cathedral Spires, Spring Morning* would seem to represent a weekday, for a small but significant detail here is the street cleaner in white, busy sweeping up at the curb—literally cleaning up the avenue. Beyond introducing class distinctions—working folk such as the street cleaner and the boy delivering flowers along with fashionably dressed pedestrians—the street cleaner also speaks to the issue of civic upkeep and the City Beautiful movement of the 1890s. More specifically, this would be one of "Waring's 'White Angels,'" so-named because of the reorganization of the city's street-cleaning department under Commissioner George E. Waring, in which each street worker was individually responsible for the maintenance of his own turf. A great deal of public outcry and printer's ink were invested in

this matter, including an article written by Waring himself.[10] Waring and Hassam may have been friends, and Hassam's occasional insertion of a street cleaner in his New York scenes was possibly a tribute to Waring.[11]

Hassam's *Cathedral Spires* captures the essence of a spring day. With trees softening the insistent geometry of the urban grid, light glistening across building facades, and pedestrians enjoying the gracious openness of the sidewalk, this luminous Impressionist scene encapsulates the optimistic attitude about urban life and the vitality of New York City at the beginning of a new century. Painted with a light, almost Pointillist touch, the painting evokes comparisons with the sparkling images of Paris that Camille Pissarro painted in the late 1890s.

Hassam's New York street promenades are among the most attractive and vital of his urban scenes; he himself declared that New York was "the most wonderful and most beautiful city in the world," and he noted that "All life is in it; the mass effects of its structure against the sky are incomparable. No street, no section of Paris or any other city I have seen is equal to New York." Of Fifth Avenue, he commented: "There is no boulevard in all Paris that compares to our own Fifth Avenue."[12] *Cathedral Spires, Spring Morning* embodies the beauty and the vigor that the artist so enjoyed in New York, and which he sought to impart to his viewers and patrons.[13]

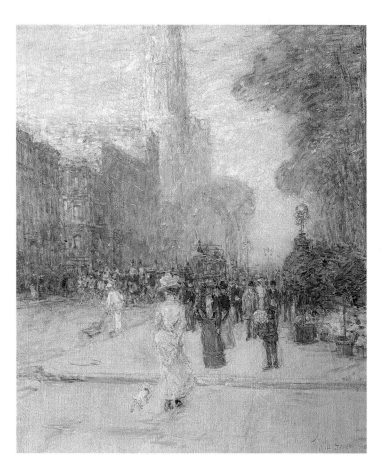

Fig. 33. Childe Hassam, *Fifth Avenue from Fifty-sixth Street Looking toward St. Patrick's*, 1900, oil on canvas, 24 × 20 inches, private collection, photograph courtesy Hollis Taggart Gallery, New York

NOTES

1. For instance, in 1907, Albert Gallatin had referred to Hassam as "beyond any doubt the greatest exponent of Impressionism in America." A[lbert] E. G[allatin], "Childe Hassam: A Note," *Collector & Art Critic* 5 (January 1907), p. 102.

2. Until the 1880s, most urban views painted by American artists consisted of panoramic vistas set within a landscape. The most significant painter to have preceded Hassam in regularly placing himself *within* the modern city was Fernand Lungren who was painting such pictures in oils and watercolor as early as 1881. He exhibited *Impressions of a Rainy Night, N. Y.* at the fourth annual exhibition of the Society of American Artists in New York that March.

3. A. E. Ives, "Talks with Artists: Mr. Childe Hassam on Painting Street Scenes," *Art Amateur* 27 (October 1892), p. 116.

4. Sadakichi Hartmann, "Art Talk. The Great American Painters," *Criterion* 16 (January 8, 1898), p. 17.

5. Mariana van Rensselaer, "Fifth Avenue with Pictures by Childe Hassam," *Century Magazine* 47 (November 1893), p. 10.

6. E. Idell Zeisloft, *The New Metropolis* (New York: D. Appleton and Company, 1899), p. 505. Zeisloft's magisterial volume is one of the most useful and important publications to offer a detailed description of New York at the turn of the century.

7. Robert A. M. Stern, Gregory Gilmartin, and John Montague Massengale, *New York 1900. Metropolitan Architecture and Urbanism, 1890–1915* (New York: Rizzoli International Publications, 1983), p. 312.

8. The painting had the Fifty-sixth Street title when it was sold from the Alexander Morten collection in 1916; see American Art Association, *Valuable Ancient and Modern Paintings the Property of Private Collectors and Several Estates* (New York: American Art Association, May 9–11, 1916), no. 116.

9. The painting is mentioned in the *Boston Daily Advertiser*, November 1, 1900, p. 4, which referred to the light, white tones of *The Cathedral and Fifth Avenue in June* but did not describe the painting further. I am grateful to Sandra Feldman for her help in this regard.

10. See Morris K. Jesup et al., *An Examination of the Subject of Street Cleaning in the City of New York* (New York: Committee on Street Cleaning, 1891); William W. Ellsworth, "Colonel Waring's 'White Angels': A Sketch of the Street-Cleaning Department of New York," *Outlook* 53 (June 27, 1896), pp. 1191–94; George E. Waring, Jr., "The Cleaning of a Great City," *McClure's Magazine* 9 (September 1897), pp. 911–24.

11. In December 1896, when Hassam was returning for a year to Europe, he sublet his Fifty-seventh Street apartment to Effie Waring, the commissioner's daughter. See De Witt Lockman interview with Hassam, January 31, 1927, typescript, The New-York Historical Society, p. 33. Among other paintings by Hassam in which a street cleaner is introduced is the best known of all his Washington Square promenades, *Washington Arch, Spring* (ca. 1893; The Phillips Collection, Washington, D.C.).

12. Childe Hassam, "New York the Beauty City," *New York Sun*, February 23, 1913, p. 16.

13. Among other promenade paintings by Hassam are his *Spring Evening—Fifth Avenue* (formerly, Hirschl & Adler Galleries, New York), and *Sunday Morning* (1897; private collection), both small pictures. *Fifth Avenue Nocturne* (The Cleveland Museum of Art) is a nighttime variation on this theme. *Central Park at Fifty-ninth Street* (1900; formerly, collection of Mr. and Mrs. Raymond J. Horowitz) might also be considered a promenade painting.

PROVENANCE

The artist, 1900–16; to [Macbeth Gallery, New York, 1916]; to Mr. Paul Schulze, Chicago, 1916–24; to Walter H. Schulze Memorial Collection, The Art Institute of Chicago, 1924–36 (in memory of Mr. Paul Schulze's son who died in World War I); by exchange, to Mr. Paul Schulze, 1936; by

descent to Miss Reba Schulze, by 1937–70; to art market, 1970; private collection, California, by 1998.

EXHIBITED

St. Botolph Club, Boston, *Exhibition of Paintings by Childe Hassam*, October 29–November 17, 1900, no. 32 (as *Cathedral and Fifth Avenue in June*); The Art Institute of Chicago, *Walter H. Schulze Gallery of American Paintings*, 1924–36, Room 47; The Buffalo Fine Arts Academy, Albright Art Gallery, New York, *A Retrospective Exhibition of Paintings Representative of the Life Work of Childe Hassam, N. A.*, March 9–April 8, 1929, no. 13 (lent by The Art Institute of Chicago).

LITERATURE

Philip Hale, "Childe Hassam's Pictures," *Boston Daily-Advertiser*, November 1, 1900, p. 4; "The Fine Arts / Paintings by Mr. Hassam at The St. Botolph Club, *Boston Evening Transcript*, November 1, 1900; "The Walter H. Schulze Memorial Gallery of Paintings," *Bulletin of the Art Institute of Chicago* 19 (January 1925), p. 9: "His *Cathedral Spires* is a pleasing arrangement of delicate color harmonies"; The Art Institute of Chicago, *The Walter H. Schulze Memorial Gallery of American Paintings* (The Art Institute of Chicago, 1930), p. 10 illus.; The Art Institute of Chicago, *A Guide to the Paintings in the Permanent Collection* (The Art Institute of Chicago, 1932), p. 156; "Childe Hassam—Painter and Graver," *Index of Twentieth-Century Artists* 3 (October 1935), p. 177; "Report of the Director / Department of Paintings and Sculpture," *Bulletin of the Art Institute of Chicago: Report for the Year 1936* (1936), p. 42.

This work will be included in the forthcoming catalogue raisonné of the work of Childe Hassam now in preparation by Stuart P. Feld and Kathleen Burnside.

Robert Henri (1865–1929)

10. *On the Marne,* 1899

 Oil on canvas
 26 × 32 inches
 Signed lower right: *Robert Henri*
 Inscribed verso: *Robert Henri / The River Bank / 30 / A / 2*

10.

Robert Henri: *On the Marne*, 1899

by Bennard B. Perlman

AMONG ALL of Robert Henri's paintings of France—the snowy streetscapes and sunny shores, the crowded cafés and glowing gardens—none can surpass his oil entitled *On the Marne* (Cat. 10). It is sufficiently praiseworthy to be labeled a masterpiece, for the combined success of its conception, brushwork, and color is unrivaled in his oeuvre.

The year 1899, when *On the Marne* was painted, was easily the most significant one in Henri's early career. Having returned to Paris for an extended honeymoon with his young bride, Linda, he wanted her to enjoy the city as he had during his student days at the Académie Julian. The apartment they rented was adjacent to the one he had occupied then, and he soon began producing cityscapes of the nearby boulevards while she sometimes sketched along with him. At the time, Henri experimented with the heightened coloration of the Impressionists and avidly read periodicals such as *La Vie Moderne* and the novels of Honoré Balzac, Emile Zola, and Leo Tolstoy, immersing himself in a study of the pressing social issues of the day.

In February 1899 he painted *La Neige* (*The Snow*) (Fig. 34), a street scene that was accepted for the Champs de Mars Salon. That honor was tempered by his wife's becoming ill, and, following the usual remedy of the day, they sought recovery in the country. Returning to Paris in June, Henri found an official-looking letter informing him that the French government wished to purchase the snow scene for its Luxembourg Museum, an honor that had been bestowed on only a handful of Americans (Whistler's portrait of his mother already hung there).

Then, in August, after Linda had a miscarriage, the couple again turned to the healing powers of the country, this time leasing a place in Alfort, three miles southeast of Paris at the confluence of the Seine and Marne rivers. Henri described the town as

> across the river from Charenton. It's practically Paris—being the East outskirts of the city on the river. Beautiful place within half an hour of the Louvre by boat and on the edge of the country in the other direction.[1]

Edward Redfield, Henri's former classmate at the Pennsylvania Academy and at Julian's, and his wife had also taken an apartment in Alfort, residing on the town's quai, and the men spent time painting together.

While Redfield concentrated on river scenes looking toward Paris, Henri gave his attention to the bridges leading across the Marne to Charenton (Fig. 35), but the most striking work he produced during his stay was *On the Marne*, in which he depicted a view looking south toward the quai of Alfort from the fourth story of a house, as he noted in his record book. Henri's modernity is reflected in his choice of subject. His site is not an old fishing village but one of Paris's suburban areas transformed as a place for middle-class leisure seekers to enjoy recreational activities. The pavilions, the rowboats waiting to be rented, and the pathways leading through the meadow that overlooked the river afforded just the sort of possibilities for healthful social and recreational activity that Parisians sought as escapes from the heat and crowds of the city. Indeed, Henri's image parallels the earlier views of Argenteuil, Bougival, and La Grenouillère painted by the French Impressionists, which had similarly documented places that expressed the essence of the new public nature and exuberant spirit of contemporary life in the late nineteenth century.

Unlike Henri's Paris cityscapes, all straight-on views in one-point perspective, in *On the Marne* he used two-point perspective, and while his street scenes were sketched at ground level, the Marne painting was created from an elevated vantage point, which accentuates the diagonal recession of the river and leads the observer into the distance. At the same time, the portions of boats that enter the composition from the lower left and right hint at action taking place offstage on the river beyond our view.

Henri's spontaneous method complemented such an instantaneous vision. Omitting excess details, he painted with broad strokes. His rich palette of forest green, olive, tan, russet, and ocher reflects his affinity with the art of Gustave Courbet, the Barbizon School, and the early work of Edouard Manet.

Fig. 34. Robert Henri, *La Neige (The Snow)*, 1899, oil on canvas, 25⅝ × 32 inches, Musée d'Orsay, Paris (formerly collection of the Musée du Luxembourg)

Fig. 35. Robert Henri, *Bridge at Charenton*, 1899, oil on canvas, 25 × 30 inches, private collection, photograph courtesy of Spanierman Gallery, LLC, New York

Both *On the Marne*'s modern subject and its stylistic treatment anticipated the work that Henri would soon produce in the United States. Settling in New York City in the summer of 1900, Henri chose as his studio / living space a house at the end of East Fifty-eighth Street, which overlooked the East River. He painted the river from a high vantage point there, too. However, the majority of those canvases, such as *East River Snow*

Fig. 36. Robert Henri, *East River Snow*, 1900, oil on canvas, 25¼ × 32 inches, Jack S. Blanton Museum of Art, The University of Texas at Austin, Texas, Gift of Mari and James A. Michener

(Fig. 36), were panoramic views of a much wider body of water, where barges or the buildings on Blackwell's Island cannot compete in charm with the juxtaposition of the French houseboat and pavilions in *On the Marne*.

When *On the Marne* was exhibited in the twenty-third annual of the Society of American Artists in the spring of 1901, critics readily recognized the distinctiveness of the painting, which Henri showed with the title *The River Bank*. The *New York Evening Post* stated that among "the long category of works that go to make this display notable ... [is] Robert Henri's scene along a populous river bank."[2] The *New York Sun* commented, "Robert Henri again, in a subject quite different, has reached delightful vivaciousness of impression: 'The River Bank' being alive with the pleasant animation of houseboats, small craft, and figures."[3] The *New York Tribune* noted that "the handful of paintings that recur as we leave the exhibition is made up of ... the sketches of Robert Henri ... which hint at the intelligent emulation of Manet and Whistler."[4] Henri also exhibited *On the Marne* in the *Fourteenth Annual Exhibition of American Painting and Sculpture* at the Art Institute of Chicago in the fall of 1901. There it attracted the attention of the critic James William Pattison, who praised Henri for presenting his subject without reverting to a conventional picturesque approach:

Henri's small-boat landing, near Paris ... shows the air, the space, and the sense of reality more than all the effort at texture in the [Eric] Pape sand pictures.... The boat-landing,

by Henri, is not a pretty picture, like those sweet pot boil-
ers of Bispham [Henry Bisbing], the cattle painter, in the
same room. I fear that most visitors think it is very unin-
teresting.... Ugliness aside, there is so much solid truth, so
much surface to the sloping grass hillside, so much space
and air.... An old houseboat, used as a landing-place for
the small boats which oarsmen amuse themselves with, is
painted green, and has felt the weather, so that the color
keeps beautiful harmony with all the play of grass tones. It
would not be right to insist that every one should admire
the blotchy manner of the brush work, one of the methods
of the Whistlerites.[5]

Indeed, it is that very "sense of reality," "solid truth," "beautiful
harmony," and "blotchy manner of the brush work" which
combine to make *On the Marne*'s wondrous mix still so appeal-
ing to us today.

NOTES

1. *Revolutionaries of Realism: The Letters of John Sloan and Robert Henri*, ed.
Bennard B. Perlman (Princeton, N.J.: Princeton University Press, 1997), p. 37.

2. B. F., "The Landscapists," *New York Evening Post*, April 8, 1901, p. 7.

3. "The Exhibition of the Society of American Artists," *New York Sun*,
April 9, 1901, p. 7.

4. "Art Exhibitions / The Society of American Artists," *New York Tribune*,
March 30, 1901, p. 6.

5. James William Pattison, "Pattison's Art Talk," *Chicago Journal*, November
16, 1901.

PROVENANCE

The artist, 1899–1929; to his wife, Mrs. Robert (Marjorie Organ) Henri,
1929–30; to the estate of Mrs. Robert Henri, 1930; to her sister, Miss Violet
Organ, 1930–54; Mr. and Mrs. Ralph Spencer, 1967.

EXHIBITED

American Fine Arts Society Galleries, New York, *Twenty-third Annual
Exhibition of the Society of American Artists*, March 30–May 4, 1901, no. 131
(p. 33, as *The River Bank*); The Art Institute of Chicago, *Fourteenth Annual
Exhibition of Oil Paintings and Sculpture by American Artists*, October
29–December 8, 1901, no. 159 (p. 30, as *The River Bank*); The Metropolitan
Museum of Art, New York, *A Memorial Exhibition of the Work of Robert
Henri*, March 9–April 19, 1931, no. 3 (p. 3, pl. 3); Whitney Museum of American
Art, New York, *New York Realists, 1900–1914*, February 9–March 5, 1937, no. 27
(p. 13); Hirschl & Adler Galleries, New York, *Robert Henri: A Commemorative
Exhibition*, March 31–April 30, 1954, no. 5; Hirschl & Adler Galleries, New
York, *Robert Henri, 1865–1929: Fifty Paintings*, February 3–28, 1958, no. 7 (as
Painted at Alfort, Southeastern Paris); The Museum of Modern Art, New
York, organizer, *The Eight*, no. 64.12 (traveled to Quincy Art Club, Illinois,
February 23–March 15, 1964; Columbia Museum of Art, South Carolina,
April 2–23, 1964; Mercer University, Macon, Georgia, May 8–29, 1964; Ten-
nessee Fine Arts Center, Nashville, July 15–27, 1964; E. B. Crocker Art Gallery,
Sacramento, California, September 6–27, 1964; Charles and Emma Frye Art
Museum, Seattle; October 18–November 8, 1964; University of Minnesota,
Minneapolis, November 23–December 20, 1964; Centennial Art Museum,
Corpus Christi, Texas, January 6–27, 1965; Theodore Lyman Wright Art Center,
Beloit College, Wisconsin, February 11–March 3, 1965; State University
College, Oswego, New York, March 15–April 10, 1965, and Roper Art Gallery,
Binghamton, New York, April 23–May 30, 1965); Sheldon Memorial Art
Gallery, University of Nebraska, Lincoln, *Robert Henri 1865–1929–1965*,
October 12–November 7, 1965, no. 6 (p. 16 illus.); New York Cultural Center
in association with Fairleigh Dickinson University, New York, *Robert Henri:
Painter-Teacher-Prophet*, October 14–December 14, 1969, no. 14 (pp. 24 illus.,
105); Hirschl & Adler Galleries, New York, *Retrospective of a Gallery: Twenty
Years*, November 8–December 1, 1973, no. 55 (illus.); Delaware Art Museum,
Wilmington, *Robert Henri: Painter*, May 4–June 24, 1984, no. 22 (pp. 52
illus., 53) (traveled to Museum of Art [now, Palmer Museum of Art], The
Pennsylvania State University, University Park, July 10–September 9, 1984;
Cincinnati Art Museum, Ohio, October 5–December 2, 1984; Phoenix Art
Museum, Arizona, January 6–February 17, 1985, and Corcoran Gallery of
Art, Washington, D.C., April 19–June 9, 1985); Spanierman Gallery, New York,
The Spencer Collection of American Art, June 13–29, 1990, no. 14 (pp. 30, 31
color illus.).

LITERATURE

James William Pattison, "Pattison's Art Talk," *Chicago Journal*, November
16, 1901; Nathaniel Pousette-Dart, comp., *Robert Henri* (New York: Frederick
A. Stokes Company, Distinguished American Artists, ca. 1922), n.p. illus.;
Helen Appleton Read, *Robert Henri* (New York: Whitney Museum of
American Art, American Artists Series, 1931), pp. 56–57 illus.; Hirschl & Adler
Galleries, New York, *Selections from the Collection, VIII* (1966), no. 27 illus.;
Bennard B. Perlman, *The Immortal Eight: American Painting from Eakins
to the Armory Show* (Cincinnati, Ohio: North Light Publishers, 1979), p. 74
illus.; Bennard B. Perlman, *Painters of the Ashcan School: The Immortal
Eight* (New York: Dover Publications, Inc., 1988), p. 74 (illus.); Bennard B.
Perlman, *Robert Henri, His Life and Art* (New York: Dover Publications, Inc.,
1991), pp. 43, 48 opposite, color illus.; Bennard B. Perlman, ed., *Revolu-
tionaries of Realism: The Letters of John Sloan and Robert Henri* (Princeton,
N.J.: Princeton University Press, 1997), pp. vii no. 13, 36 no. 13 illus., 37, 38
note 4, 49 note 2.

On the Marne is documented in Robert Henri's "Record Book A" (unpub-
lished manuscript, 30/A/2), p. 30 (second item on page), estate of the artist.

Frederic Remington (1861–1909)

11. *The Cheyenne*, cast no. 10, 1903

Bronze, black patina
18¼ × 24 × 8 inches; base 7³⁄₁₆ × 14¾ inches
Signed lower left: *© 1903 by Frederic Remington*
Copyright, on top of base: *Copyright by / Frederic Remington*
Foundry, on side of base : ROMAN BRONZE WORKS N-Y-
Number, underneath the bottom of the base: *No. 10*

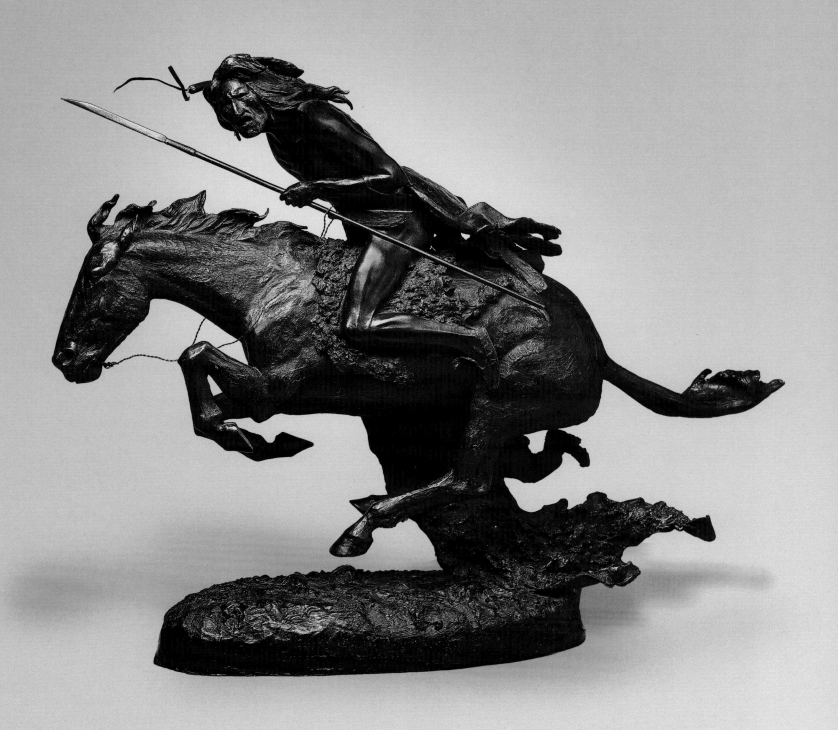

Frederic Remington: *The Cheyenne*, cast no. 10, 1903

by Peter H. Hassrick

NEXT TO COWBOYS, Indians were Frederic Remington's favorite theme in sculpture. In a sculptural career that lasted only fourteen years, he produced six separate bronzes of Indian subjects beginning with *The Scalp* (initially copyrighted in 1898) and culminating in *The Savage* (1908). Together, these six works reveal the artist's fascination with America's native people. By including them so prominently in his expansive narrative oeuvre, Remington indicates his respect (one might even say awe) for their role in the unfolding national epic on which he focused his creative attentions. Of all his Indian-related bronzes, the most popular was his spirited rendition of a Cheyenne.[1]

Remington had long admired the Cheyenne people. As a young illustrator in 1888 he had spent four days among them at Fort Reno in Indian Territory. There he sketched and photographed the reservation life of the Cheyenne and, through an interpreter, Ben Clark, collected stories of their past. Shortly after his return home to New York, Remington painted a dramatic picture to illustrate a story by Frank W. Calkins for *The Youth's Companion*.[2] Entitled *Unwelcome Visitors* (Fig. 37), it depicts a group of mounted warriors riding toward the viewer. The foremost figure—with his raised spear, menacing glare, and horse at full gallop—is a provocative antecedent to Remington's second most popular bronze, *The Cheyenne*, which he copyrighted in 1901. The painting even depicts all four feet of the running horse off the ground, which in 1888 was a bold statement,

supported as it was for veracity only by Eadweard Muybridge's recent photographic experiments. For the sculptor, a dozen years later, such a depiction was a true tour de force.

At Fort Reno, Remington had "met many Cheyennes riding someplace or another. They were almost invariably tall men with fine Indian features," as delineated in his facile drawing, *A Cheyenne* (Buffalo Bill Historical Center, Cody, Wyoming). He saw them as "anything but graceful on horseback," but confessed that he admired their agility and ability as equestrians. Although they would not pass muster with an "Eastern riding-master," he concluded, "they do ride splendidly."[3]

In subsequent years Remington continued to associate with the Cheyenne. As an artist-correspondent at the Battle of Wounded Knee in 1890, he rode beside them against the beleaguered Sioux. He was again impressed with their horsemanship, their valor, and their perseverance under conditions of campaigning in winter. The Cheyenne served as scouts for the U.S. Army, and although scouting has proven historically to be somewhat ignominious, Remington celebrated their skills as warriors and their loyalty to the cause at hand.[4]

When Remington chose in 1901 to acknowledge his great respect for the Cheyenne with a bronze, he portrayed them in the figure of a mounted warrior riding against an unknown foe. His colleague and sometime competitor, Solon H. Borglum, had recently won international accolades with his bronze *On the Border of White Man's Land* (Fig. 38), which had been awarded a silver medal at the Universal Exposition in Paris in 1900. Borglum's piece showed one of Custer's favorite scouts, probably a Crow, dismounted and peering over a bluff at some distant adversary.[5] The scene overflows with portent, an engagement powerfully foretold in the postures and focus of the man and horse. Following his assertion that "sculpture is the most perfect expression of action," Remington elected to exploit the tension latent in the Borglum work by literally thrusting his horse and rider into midair.[6] Rejoicing in the unity of motion between the rider and his galloping mount and in the dynamic of all-out momentum, Remington portrayed his Cheyenne in the rush of battle. The artist enhanced the spirit of his two-dimensional work and laid claim to a new direction in American sculpture. He was endeavoring to duplicate the accolades he had won ten years before with his illustrations, when the critic William A. Coffin had written that "[I]n his pictures of life on the plains and of Indian fighting, he has almost created a new field in illustration, so fresh and novel are his characterizations."[7]

In the spring of 1901 Remington had a serious fall from a horse that left him incapacitated for several weeks. Chair-ridden, he worked on the plasticine model for his dramatic sculpture

Fig. 37. Frederic Remington, *Unwelcome Visitors* (also known as *Pursuit* and *Attacking War Party*), ca. 1888, oil on board, 16 × 19 inches, 21 Club Collection, New York

Fig. 38. Solon H. Borglum, *On the Border of White Man's Land*, 1900, bronze, 19 inches high, The Metropolitan Museum of Art, New York, Rogers Fund, 1907

The Cheyenne (Cat. 11), with his own leg splinted and his foot elevated. Shortly before the plaster molds were taken, he wrote to his friend Owen Wister, inviting the writer to come and view the model. "Would like to have you drop in on me—for a night..... Show you a mud of an indian & a pony which is burning the air—I think and hope he won't fall off as I did—he had a very teetery seat and I am nervous about even mud riders."[8]

To exploit the pose of the two figures completely, the sculptor wanted the horse presented with all four feet off the ground. So far as he knew, no artist had ever achieved this effect without resorting to a supporting rod. Remington's solution was to drape a buffalo robe off the right side of the horse, which, though a somewhat unlikely adjunct to such a scene, was an effective and innovative experiment. He wrote a note to his foundry man, Riccardo Bertelli, at the Roman Bronze Works, asking if such a supportive device would work (Fig. 39). The answer was "yes."

Bertelli had been employed by Remington because his foundry used the lost-wax method of casting, the first firm in America to do so. Remington had produced one other piece, *The Norther* (copyrighted in 1900), with Bertelli. It was a highly textural work but did not nearly approach the complexity of composition explored in *The Cheyenne*. The successful achievement of casting the Indian and rider charging through space placed Remington in the vanguard of American sculptors. The high relief of the robe also proved the medium's potential for textural variation and detail.

So complicated and delicate was the piece that Bertelli was asked to "send the best man you have to do the plaster" to Remington's New Rochelle studio rather than chance the trip south with the clay model to the Brooklyn foundry.[9] The first waxes were made in the fall of 1901, and the bronze was copyrighted in November of that year. The finished pieces were placed on the shelves of Tiffany's and tagged with Remington's

asking price of $250, the same amount as *The Broncho Buster* that was also offered for sale there.

Through the next several years, Remington made changes to the bronze, especially in the position of the shield on the rider's back and the coloration. Given the experimental nature of the composition, one would think that Remington might have been sufficiently challenged with that alone. But he also used this piece to explore multiple approaches to patination both in color and in variation of color over texture. Cast number 3 at the Denver Art Museum, for example, features a lovely golden honey color, while cast number 9 at the Buffalo Bill Historical Center is golden with a delicate wash of green. For this cast, number 10, Remington elected to return to his favorite, a greenish black with highlights of the natural bronze showing through in certain prescribed places.

Although Remington did not re-copyright the bronze, nonetheless the copyright inscriptions change on the early works. Cast number 3 is marked with a copyright of 1901, cast number 9 with 1902, and cast number 10 with 1903. Remington broke the molds for *The Cheyenne* in 1907, at which point twenty had been cast. He then reworked the model and produced another four or five in his lifetime from new molds.

This bronze is a testament to Remington's special affection for the Cheyenne. At the time he produced his first bronze of the subject he also completed a full-length novel as a tribute to their history and the hardships of recent generations. Entitled *The Way of an Indian*,[10] it recounted the adventures and long-suffering heroics of a fictional young Chis-Chis-Chash (Cheyenne) man, White Otter, whose life spans the arrival of the white man to the Northern Plains. Many of the paintings that illustrate the book, especially *He Rushed the Pony to the Barricade* (Fig. 40), are closely associated with *The Cheyenne* sculpture in theme and pose. Perhaps the figure on the galloping horse is Remington's White Otter in enduring bronze.

Fig. 39. Frederic Remington, illustrated letter, ca. 1901, private collection, published in *Cast and Recast: The Sculpture of Frederic Remington* (Washington, D.C.: Smithsonian Institution Press, 1981), p. 49

Fig. 40. Frederic Remington, *He Rushed the Pony to the Barricade*, 1901, oil on canvas, 27 × 40⅛ inches, Sid W. Richardson Collection of Western Art, Fort Worth, Texas

NOTES

1. According to the sales records in Remington's ledger books dated May 9, 1907, his most popular bronze was *The Broncho Buster* (1895), of which 66 had sold. *The Cheyenne* ranked next, with sales of 20. See Michael Shapiro and Peter H. Hassrick, *Frederic Remington: The Masterworks* (New York: Harry N. Abrams, Inc., 1988), p. 267.

2. Frank W. Calkins, "Sequapah," *Youth's Companion* 61 (September 27, 1888), p. 459. Although the story featured Sioux and Pawnee, the illustration was more than likely inspired by his observations of Indian horsemanship among the Cheyenne.

3. Frederic Remington, "Artist Wanderings among the Cheyennes," *Century Magazine* 38 (August 1889), p. 538.

4. Frederic Remington, "Lieutenant Casey's Last Scout on the Hostile Flanks with Chis-Chis-Chash," *Harper's Weekly* 35 (January 31, 1891), pp. 85–87.

5. Frank Sewall, "A Sculptor of the Prairie," *Century Magazine* 68 (June 1904), p. 251.

6. Perrington Maxwell, "Frederic Remington—Most Typical of American Artists," *Pearson's Magazine* 18 (October 1907), p. 407.

7. William A. Coffin, "American Illustration of To-Day," *Scribner's Magazine* 11 (March 1892), p. 348.

8. Letter from Remington to Wister, undated [ca. 1901], in the Owen Wister Papers, Library of Congress.

9. Quoted in Peggy Harold Samuels, *Frederic Remington: A Biography* (Garden City, N.Y.: Doubleday & Company, 1982), p. 317.

10. Frederic Remington, *The Way of An Indian* (New York: Fox Duffield & Company, 1906). The manuscript and illustrations for this book were completed during the summer of 1901. They were originally published in serial form in the *Cosmopolitan* in 1905.

PROVENANCE

Private collection; [James Graham & Sons, Inc., New York, 1972]; John Davenport, Jr., Chattanooga, Tennessee, 1975; private collection, Chattanooga, Tennessee.

LITERATURE

(references to all lifetime casts of Remington's *Cheyenne*)

Perrington Maxwell, "Frederic Remington—Most Typical of American Artists," *Pearson's Magazine* 18 (October 1907), p. 407; *Life Magazine* (September 14, 1942), p. 72 illus.; H. L. Card, *The Collector's Remington, a Series: II, The Story of His Bronzes, with a Complete, Descriptive List for the Collector* (Woonsocket, R.I.: H. L. Card, 1946), pp. 4, 9 (no. 8, as *The Cheyenne* [*The Cheyenne Warrior*]); Harold McCracken, *A Catalogue of The Frederic Remington Memorial Collection* (New York: The Knoedler Galleries for The Remington Art Memorial, 1954), pp. 69 (no. 70), 70 pl. 18 (illus. at lower right); Harold McCracken, *The Frederic Remington Book: A Pictorial History of the West* (Garden City, N.Y.: Doubleday and Company, 1966), p. 260 (no. 367) illus.; Bruce Wear, *The Bronze World of Frederic Remington* (Tulsa, Okla.: Gaylord Art Americana, 1966), p. 66; Peter Hassrick, *Frederic Remington: Paintings, Drawings, and Sculpture in the Amon Carter Museum and the Sid W. Richardson Foundation Collections* (New York: Harry N. Abrams, in association with the Amon Carter Museum of Western Art, 1973), no. 63 color illus. (cast no. 80); The R. W. Norton Art Gallery, Shreveport, Louisiana, *Frederic Remington (1861–1909): Paintings, Drawings, and Sculpture in the Collection of the R. W. Norton Art Gallery* (Shreveport, La.: The R. W. Norton Art Foundation, 1979), pp. 71 (no. 48) illus. (cast no. 1), 72 (no. 49) illus. (cast no. 15); Michael Edward Shapiro, *Cast and Recast: The Sculpture of Frederic Remington* (Washington, D.C.: National Museum of American Art, Smithsonian Institution Press, 1981), pp. 46–47, 48 fig. 28 (cast no. 3, Denver Art Museum), 49 fig. 29 (pen and ink sketch for *The Cheyenne*, Harold McCracken Collection, Buffalo Bill Historical Center, Cody, Wyoming), 51, 53; Michael Edward Shapiro and Peter H. Hassrick, *Frederic Remington: The Masterworks* (New York: Harry N. Abrams, in association with the Saint Louis Art Museum and the Buffalo Bill Historical Center, 1988), pp. 193 color pl. 55 (cast no. 3, Denver Art Museum), 195, 196–97 detail color illus., 198–99, 206, 210, 214, 218, 221, 227, 267; Allen P. Splete and Marilyn D. Splete, *Frederic Remington: Selected Letters* (New York: Abbeville Press, 1988), pp. 296 note 2, 309, 322 note 2, 323, 330, 391; James K. Ballinger, *Frederic Remington* (New York: Harry N. Abrams, in association with the National Museum of American Art, Smithsonian Institution, 1989), pp. 103, 105 color illus. (cast no. 3, Denver Art Museum); Dean Krakel, *Dear Mr. Remington: Twenty-one Letters from the West* (Corning, N.Y.: Rockwell Gallery, 1991), pp. 16, 74, 113 note 23; Rick Stewart, *Frederic Remington: Masterpieces from the Amon Carter Museum* (Fort Worth, Tex.: Amon Carter Museum, 1992), pp. 34–35 color illus. (cast no. 20); Michael D. Greenbaum, *Icons of the West: Frederic Remington's Sculpture* (Ogdensburg, N.Y.: Frederic Remington Art Museum, 1996), pp. 16, 33, 35, 56, 88 fig. 1 (illus. cast no. 3), 89, 90 figs. 2–4 (illus. pen and ink sketch, Harold McCracken Collection, Buffalo Bill Historical Center, Cody, Wyoming; *A Fantasy from the Pony War Dance*, a related pen and ink illus. published in *Harper's Monthly*, 1891, and rear view, cast no. 4, private collection), 91.

Willem de Kooning (1904–1997)

12. *East Hampton IV,* 1977

 Oil on canvas
 30 × 36 inches
 Signed on the verso: *deKooning*

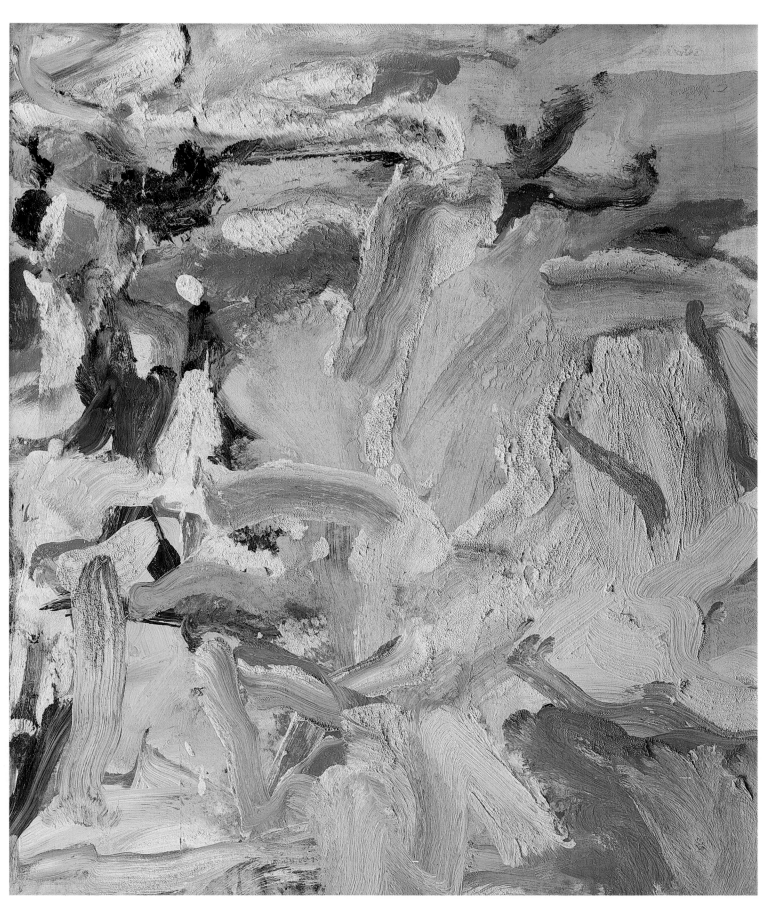

Willem de Kooning: *East Hampton IV*, 1977

by Donald Kuspit

IN 1961 WILLEM DE KOONING purchased a cottage in the Springs in East Hampton. In 1963 he moved permanently to East Hampton, giving up his New York studio. After that time, off and on, he consistently painted the East Hampton environment.[1] Indeed, it became the major site of the "no-environment," as he called the space around his figures. As Jörn Mekert suggests, this was an expressive and physical wilderness for de Kooning, and as such the imaginary space par excellence of painterly license and "psychic improvisation."[2] De Kooning apparently associated it with the space between city and country, a marginal space where the "fleeting things … one passes" make an "impression," where "sensations" of "landscapes and highways" commingle, where a certain content is glimpsed but too transient to nail down.[3] Its details spatter in perception, evoking the emotions aroused by the scene rather than describing the scene itself.

"I'm just crazy about going over the roads and highways," de Kooning said, no doubt because of the sense of freedom it gave him. As he implied, the "pictures done since the Women" are about the "emotions" aroused by such travel—such apparently random, directionless, "crazy" movement through a landscape at once physically tangible and emotionally intangible. Matter and emotion were equally fast-paced and precarious and almost indistinguishable in it—equally fluid, irrational, elusive yet oddly in touch with real space, and really experienced. After he left New York, East Hampton became de Kooning's emotional no-environment, as well as his daily physical environment. He recorded its unpredictable sensations as carefully as Cézanne had documented those of Mont St. Victoire. In a sense, de Kooning's move from New York to East Hampton and Cézanne's move from Paris to Aix-en-Provence were parallel searches for emotional salvation in nature. Putting down roots in nature, each could finally find his true self.[4]

Their sensations are radically different in kind, no doubt in part because their psyches and histories were different, and in part because Long Island and Southern France are different terrains—the former is flat, the latter mountainous. But the subjective principle involved in their approach to the landscape is the same. They both found emotional freedom in it, while respecting its objectivity. De Kooning continues the obsession with emotionally charged sensation of the actual that Cézanne began and brings it to a climax beyond anything that Cézanne imagined.

East Hampton, IV (Cat. 12) is a compact rendering of de Kooning's no-environment, indeed, a kind of eloquent distillation of it. The painting's broad, flat gestures bespeak the Long Island landscape, and its complicated movement echoes de Kooning's excited experience of its contradictions. However abstract and autonomous, the gestures are like pieces of highway and landscape in one singular flash of synthesizing movement. "De Kooning's paintings are based on contradictions kept contradictory in order to reveal the clarity of ambiguities," Thomas Hess wrote, "the concrete reality of unanswered questions, the unity of simultaneity and multiplicity."[5] *East Hampton IV* illustrates this, but it also shows that de Kooning's contradictions and ambiguities are rooted in nature—perceived rather than invented, a consequence of sometimes rapid, sometimes slow, contemplation of a landscape rather than a deliberate attempt to be intellectually puzzling. Similarly, however much de Kooning's paintings are full of anxious abandoned acts, as Harold Rosenberg said,[6] their painterly action belongs to nature as much as it is an expression of de Kooning's anxiety. And while, as Clement Greenberg would say, *East Hampton IV* is an allover painting, it also mediates an oceanic experience of nature—a kind of symbiotic immersion in nature.

East Hampton IV has passages of great delicacy and fragility, evident particularly in the pink gestures that relate to flesh, which, as de Kooning famously said, "was the reason why oil painting was invented."[7] These alternate with more eruptive, brusque gestures of green, red, and yellow. All are embedded in

Fig. 41. John Mallord William Turner, *Rain, Steam, and Speed—the Great Western Railway* (detail), 1844, oil on canvas, 35⅞ × 48 inches, National Gallery, London, Turner Bequest

Fig. 42. Erich Heckel, *Glassy Day* (detail), 1913, Staatsgalerie Modernekunst, Munich / Artothek

and sometimes fade into a luminous white, which is the subliminally—and not so subliminally—prevailing tone, particularly in the lower half of the canvas. It is hard to make a whiteness that is convincingly intense and animated—that does not disappear into the canvas, or remind one of it—but de Kooning succeeds in doing so. He accomplishes this in part through the variety of textures that inform his white gestures, making their luminosity seem differentiated, and by the way they unexpectedly appear in the upper half of the canvas, where they hold their own against the strong surrounding colors.

Indeed, it is the disruptive unexpectedness—apparent unpredictability—of de Kooning's gestures that give his paintings their aura of absolute spontaneity, and in *East Hampton IV* it is the white gestures that seem to carry the burden of unpredictability more than the others. It is as though de Kooning gives us a cross section of the light in one of Turner's last paintings—a bit of tissue of light—and shows it to be swarming with expressive life (Fig. 41). I am suggesting that the observation and experience of nature are generally at the root of de Kooning's paintings, and that *East Hampton IV* is an intimate landscape of natural light. The earthly and unearthly mingle in a kind of dynamic panorama of gestures, each emblematic of an aspect of nature. Indeed, de Kooning's painting extends and deepens the romantic perception of nature as a panorama of movements, and the Impressionist perception of light as a panorama of colors. Yellow and red are primary colors, but they are also the colors of the sun as it rises and sets—of different kinds of incandescence—and white light is the purest of all, and the color of the sun at its height.

East Hampton IV is then first and foremost a landscape painting, however much it is also pure painting, and like all landscape paintings it conveys the intricate, occult balance implicit in landscape—the unity latent in the urgent chaos of its details. Indeed, it is the wish and search for a balance that does not always exist in the self that motivates landscape painting, which at least since the Romantics has been a metaphor for the self at its most complex and dynamic. In *East Hampton IV* the broad white and yellow gestures of the central area rise from the lower edge and are framed by shorter, brisker gestures, spreading out toward the upper edge and sides. It is as though de Kooning pulled the woman he usually depicts out of the picture, leaving behind the perfume of her sensation and the residue of the excitement she arouses. It is well known that for de Kooning woman's body became a landscape, and landscape was experienced as woman's body—a not unfamiliar idea, nature being female in myth. The idea of a figure centered in an environment is implicit, and it is in part responsible for the subliminal sense of control and unity and construction—as well as expression—in *East Hampton IV*. Beyond that, gesture plays against gesture, in terms of color, fluidity, and extent, all within the containment of the easel-sized canvas, which forces the gestures together whether they want to be or not. There is a sense of layering that adds depth, and a dialectic of centrifugal and centripetal—disintegrative and integrative—movements that create a sense of difference within unity. De Kooning resolves his contradictions, however covertly.

De Kooning once said, no doubt with a certain irony, that "what fascinates me [is] to make something that you will never

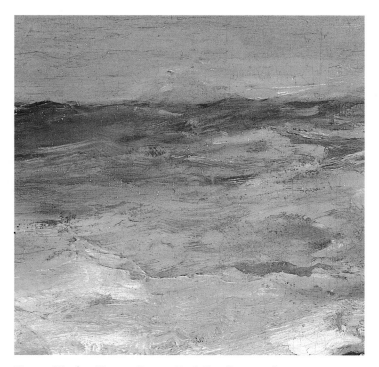

Fig. 43. Winslow Homer, *Cannon Rock* (detail), 1893, oil on canvas, 40 × 40 inches, The Metropolitan Museum of Art, New York, Gift of George A. Hearn, 1906

be sure of, and no one else will either,"[8] but we can be sure that *East Hampton IV* is a small masterpiece. It is a consummate slice of instinctive painting, best compared, not with Jackson Pollock's mural-sized allover paintings, as one might expect, but, strange as it may sound, with such German Expressionist masterpieces as Franz Marc's *Tirol* of 1913–14, (Staatsgalerie Moderne Kunst, Munich)—already an Abstract Expressionist work, full of the same "pantheistic empathy" as de Kooning's painting—Erich Heckel's *Glassy Day* of 1913 (Fig. 42), and Emil Nolde's *Marsh Landscape* (*Evening*) of 1916 (Basel Kunstmuseum). Yes, it even makes sense to go back to de Kooning's Dutch ancestor Vincent Van Gogh's landscapes to understand what *East Hampton IV* carries to a risky extreme, and why it has as much to do with a European expressionist sensibility as an American experience of landscape. For de Kooning also finishes what Winslow Homer began in his late wild landscapes of the surging sea (Fig. 43).[9]

PROVENANCE

[Xavier Fourcade, Inc., New York, 1977]; to Dr. and Mrs. Robert Mandelbaum, by 1978–80; (Sotheby's, New York, November 9, 1989, lot 160); private collection.

EXHIBITED

Xavier Fourcade, Inc., New York, *De Kooning: New Paintings*, October 11–November 19, 1977; The Solomon R. Guggenheim Museum, New York, *Willem de Kooning in East Hampton*, February 10–April 23, 1978, no. 45, (p. 74 color illus.); Museum of Art, Carnegie Institute, Pittsburgh, *Willem de Kooning: Pittsburgh International Series*, October 26, 1979–January 6, 1980, no. 53, (p. 84 color illus.); Nassau County Museum of Art, Roslyn, New York, *Intimates and Confidants in Art*, February 27–May 23, 1993;

LITERATURE

David Shirey, "De Kooning and the Island's Spell," *New York Times*, Long Island Section, February 5, 1978, p. 14; Mark Stevens, "De Kooning in Bloom," *Newsweek*, February 20, 1978, pp. 92–93.

NOTES

1. De Kooning had painted in East Hampton before, for example, in the summer of 1952, when he executed a particularly noteworthy series of pastels of the female figure. But he had not painted East Hampton itself, or rather the emotions its landscape evoked in him, nor had he painted there full-time.

2. Jörn Mekert, "Stylelessness as Principle: The Painting of Willem de Kooning," *Willem de Kooning: Drawings, Paintings, Sculpture*, exh. cat. (New York: Whitney Museum of American Art in association with Munich: Prestel and New York: Norton, 1984), pp. 126, 125.

3. Willem de Kooning, "Content is a Glimpse," in Thomas B. Hess, *Willem de Kooning* (New York: The Museum of Modern Art, 1968), pp. 148–49.

4. Harold Rosenberg, "De Kooning: On the Borders of the Act," in *The Anxious Object* (New York: Horizon, 1964), p. 127, thought that de Kooning was always looking for the gesture that would bring him "closer to his true self, that is, to something in him he did not know was there." More to the point, D. W. Winnicott regards "the spontaneous gesture and the personal idea" as signs of the true self. De Kooning was in relentless search for them. See "Ego Distortion in Terms of True and False Self," in *The Maturational Processes and the Facilitating Environment* (New York: International Universities Press, 1965), p. 148.

5. Thomas B. Hess, *Willem de Kooning* (New York: George Braziller, 1959), p. 7

6. Rosenberg, "On the Borders of the Act," p. 125

7. Quoted in Mekert, "Stylelessness as Principle," p. 115.

8. Quoted in David Anfam, *Abstract Expressionism* (New York and London: Thames and Hudson, 1990), p. 179.

9. Mekert, "Stylelessness as Principle," p. 129, concludes his discussion of de Kooning's use of landscape as "inscape"—a term invented by Gerard Manley Hopkins—by arguing that de Kooning conveys, in abstract form, the same sensory vision of nature as Courbet's *Wave* (1870; Staatliche Museen Preustestischer Kulturbesitz, Nationalgalerie, Berlin), and with the same physical means. Mekert singles out de Kooning's nature paintings of 1975–79 as particularly climactic in their communication of "sensory experiences of nature . . . with almost physical immediacy." *East Hampton IV* was painted in 1977.

Contributors

H. Nichols B. Clark is the chairman of the Education Department at the High Museum of Art, Atlanta, Georgia. He has held positions at the National Gallery of Art, Washington, D.C., the Lamont Gallery at Phillips Exeter Academy, Exeter, New Hampshire, and the Chrylser Museum of Art, Norfolk, Virginia. Clark received his B.A. from Harvard University, Cambridge, Massachusetts, and his M.A. and Ph.D. from the University of Delaware, Wilmington. His publications include *A Marble Quarry: The James H. Ricau Collection of Sculpture at the Chyrsler Museum of Art* (1997).

William H. Gerdts is professor of art history at the Graduate School of the City University of New York, where he has taught for twenty-eight years. He has held many previous museum and teaching posts: he has taught at the University of Maryland and was curator of painting and sculpture at the Newark Museum, New Jersey, for twelve years. He received his B.A. from Amherst College, Massachusetts, and his Ph.D. from Harvard University, Cambridge, Massachusetts. His extensive writings in the field of American art encompass numerous articles and books, including *American Neo-Classic Sculpture: The Marble Resurrection* (1973), *Painters of the Humble Truth: Masterpieces of American Still-Life, 1801–1939* (1981), *American Impressionism* (1984), *Grand Illusions: History Painting in America* (with Mark Thistlewaite, 1988), *Art Across America* (1990), *Monet's Giverny: An Impressionist Colony* (1993), *William Glackens* (1996), *Impressionist New York* (1994), and *California Impressionism* (with Will South, 1998).

Peter H. Hassrick is the Charles M. Russell professor of American western art at the University of Oklahoma, Norman, and the director of the university's Western Art Study Center. He was the founding director of the Georgia O'Keeffe Museum in New Mexico, and for the prior twenty years, he served as director of the Buffalo Bill Historical Center in Cody, Wyoming. He received his B.A. from the University of Colorado, Boulder, and his M.A. from the University of Denver, where his concentration was nineteenth- and early-twentieth-century American art. Hassrick's books include *Frederic Remington* (1973), *The Way West* (1977), *The Rocky Mountains: A Vision for Artists in the Nineteenth Century* (with Patricia Trenton, 1983), *Treasures of the Old West* (1984), *Charles Russell* (1989), *Frederic Remington: A Catalogue Raisonné of Oils, Watercolors, and Drawings* (with Melissa Webster, 1996), and *The Georgia O'Keeffe Museum* (1997).

Donald Kuspit is professor of art history and philosophy at the State University of New York at Stony Brook, and A. D. White professor-at-large at Cornell University, Ithaca, New York. He has doctorates in philosophy (University of Frankfurt) and art history (University of Michigan), as well as degrees from Columbia University, Yale University, and Pennsylvania State University. One of America's most distinguished art critics, Kuspit is a contributing editor of *Artforum*, *Sculpture*, and the *New Art Examiner* magazines and the editor of *Art Criticism*. He has written numerous articles, exhibition reviews, and catalogue essays. His many books include *The New Subjectivism: Art in the 1980s* (1988), *The Cult of the Avant-Garde Artist* (1993), *The Dialectic of Decadence* (1993), *Primordial Presences: The Sculpture of Karel Appel* (1994), *Signs of Psyche in Modern and Postmodern Art* (1994), *Health and Happiness in Twentieth-Century Avant-Garde Art* (with Lynn Gamwell, 1996), *Idiosyncratic Identities: Artists at the End of the Avant-Garde* (1996), and *Joseph Raffael* (1998).

Carol Lowrey is curator of the permanent collection at The National Arts Club, New York, and research associate at Spanierman Gallery, LLC, New York. She received master's degrees in art history and in library and information science from the University of Toronto and is currently a doctoral candidate in art history at the Graduate School of the City University of New York. Lowrey has written numerous articles, essays, and catalogues relating to nineteenth- and early-twentieth-century American and Canadian painting, including *Visions of Light and Air: Canadian Impressionism, 1885–1920* (Americas Society Art Gallery, New York, 1995) and *A Noble Tradition: American Paintings from The National Arts Club Permanent Collection* (Florence Griswold Museum, Old Lyme, Connecticut, 1995). Lowrey is currently preparing a catalogue of The National Arts Club's collection of paintings.

Elizabeth Milroy teaches art history and American studies at Wesleyan University, Middletown, Connecticut. She received her doctorate from the University of Pennsylvania. Her dissertation, "Thomas Eakins's Artistic Training," was instrumental in acquiring (with Kathleen Foster) Charles Bregler's Thomas Eakins Collection for the Pennsylvania Academy of the Fine Arts. Her publications include *Painters of a New Century: The Eight and American Art* (Milwaukee Art Museum, 1991) and a monograph on Emma Stebbins (*Archives of American Art Journal*, 1993–94). She coedited *Reading American Art*, an anthology of essays on American painting, sculpture, and photography (with Marianne Doezema). Milroy is currently writing a history of Philadelphia's Fairmount Park system and will be contributing an essay to the catalogue for the Eakins retrospective being organized by the Philadelphia Museum of Art (2001).

Elwood C. Parry III has been a professor of art history at the University of Arizona, Tucson, since 1981. Previously he taught at Columbia University and the University of Iowa. He received his B.A. from Harvard University, Cambridge, Massachusetts, his M.A. in art history from the University of California, Los Angeles, and his Ph.D. from Yale University, New Haven, Connecticut. He is the author of *The Image of the Indian and the Black Man in American Art, 1590–1900* (1974) and *The Art of Thomas Cole: Ambition and Imagination* (1988).

Bennard B. Perlman served as professor of art and chairman of the Department of Fine and Applied Arts at the Baltimore City Community College for thirty-two years, prior to his retirement in 1986. He received his B.A. from Carnegie Institute of Technology (now Carnegie Mellon University) and his M.A. in art history from the University of Pittsburgh. He completed additional graduate studies in art history at the Johns Hopkins University. Professor Perlman has written scores of articles on American art. His books include *The Immortal Eight: American Painting from Eakins to the Armory Show* (1962), *1% Art in Civic Architecture* (1972), *The Golden Age of American Illustration: F. R. Gruger and His Circle* (1978), *Robert Henri: His Life and Art* (1991), *Revolutionaries of Realism: The Letters of John Sloan and Robert Henri* (1997), and *The Lives, Loves, and Art of Arthur B. Davies* (1998).

Lisa N. Peters is director of research at Spanierman Gallery, New York, and coauthor of the forthcoming catalogue raisonné of the work of John Henry Twachtman (with Ira Spanierman). She received her B.A. from Colorado College and her Ph.D. in art history from the Graduate School of the City University of New York. Her recent publications include an essay in *John Twachtman: Connecticut Landscapes* (National Gallery of Art, Washington, D.C., 1989), *American Impressionist Masterpieces* (1991), *James McNeill Whistler* (1996), *A Personal Gathering: Paintings and Sculpture from the Collection of William I. Koch* (Wichita Art Museum, 1996), *Visions of Home: American Impressionist Images of Suburban Leisure and Country Comfort* (Dickinson College, Carlisle, Pennsylvania, 1997), and the forthcoming *John Twachtman: An American Impressionist* (High Museum of Art, Atlanta, Georgia, 1999).

Ronald G. Pisano is an art historian and consultant specializing in American painting of the late nineteenth and early twentieth centuries. He has served as curator and director of the Parrish Art Museum, Southampton, New York; as guest curator of the Museums of Stony Brook, Stony Brook, New York; and as consultant curator of American art for the Heckscher Museum, Huntington, New York. Pisano received degrees from Adelphi University, Garden City, New York, and the University of Delaware, Wilmington. His publications include *William Merritt Chase* (1979); *A Leading Spirit in American Art: William Merritt Chase, 1849–1916* (1983); *Long Island Landscape Painting, 1820–1920* (1985); *Long Island Landscape Painting—Volume II: The Twentieth Century* (1990); and *Summer Afternoons: Landscape Paintings of William Merritt Chase* (1993). Currently he is working on a catalogue raisonné of Chase's work.

Erik Ronnberg is a ship modelmaker, who builds ship models for museums and private collectors. Previously he held several curatorial positions at the New Bedford Whaling Museum, Massachusetts. He has a degree in biology from Long Island University in Southampton and completed the Newark Museum's training program in museum studies. Ronnberg has published extensively in journals and books on many aspects of nautical history and the use of ship models in nautical research. Long interested in the work of Fitz Hugh Lane, he contributed an essay to the catalogue *Paintings by Fitz Hugh Lane* (National Gallery of Art, Washington, D.C., 1988).

Ira Spanierman is the director of Spanierman Gallery, LLC, New York, which for over fifty years has been dedicated to dealing in the finest American paintings, drawings, and sculpture of the nineteenth and twentieth centuries. Some important exhibitions held recently at the gallery include *Twachtman in Gloucester: His Last Years, 1900–1902* (1987); *Frank W. Benson: The Impressionist Years* (1988); *In the Sunlight: The Floral and Figurative Art of J. H. Twachtman* (1989); *Ten American Painters* (1990); *American Painters in Giverny, 1885–1920* (1993); *William Merritt Chase: Master of American Impressionism* (1994–95); *Willard Leroy Metcalf: An American Impressionist* (1995–96); *Painters of Cape Ann, 1840–1940: One Hundred Years in Gloucester and Rockport* (1996); *Wilfrid-Gabriel de Glehn: John Singer Sargent's Painting Companion* (1997); and *Theodore Wores: Paintings from California to Japan* (1998). Spanierman is currently coauthor of three forthcoming catalogues raisonnés, on John Henry Twachtman, Theodore Robinson, and Willard Metcalf. He is also sponsoring the Lloyd Goodrich, Edith Havens Goodrich, and Whitney Museum of American Art catalogue raisonné of the work of Winslow Homer. In addition, he is president of the Thomas Cole Foundation.

Index to Illustrations

Photograph Credits

Catalogue 1–12, Figures 7, 11, 27, 35, 37: Roz Akin
Figure 2: © The Cleveland Museum of Art
Figure 10: © Virginia Museum of Fine Arts
Figure 13: Larry Burgess
Figures 18, 19: Lee Stalsworth
Figure 25: David Preston
Figure 36: George Holmes

Design: Marcus Ratliff
Composition: Amy Pyle
Editor: Fronia W. Simpson
Imaging: Center Page
Lithography: Meridian Printing

ENDLEAF:
Thomas Cole, *Sunset on the Arno* (detail of Cat. 1)